A Little Bit of Paris

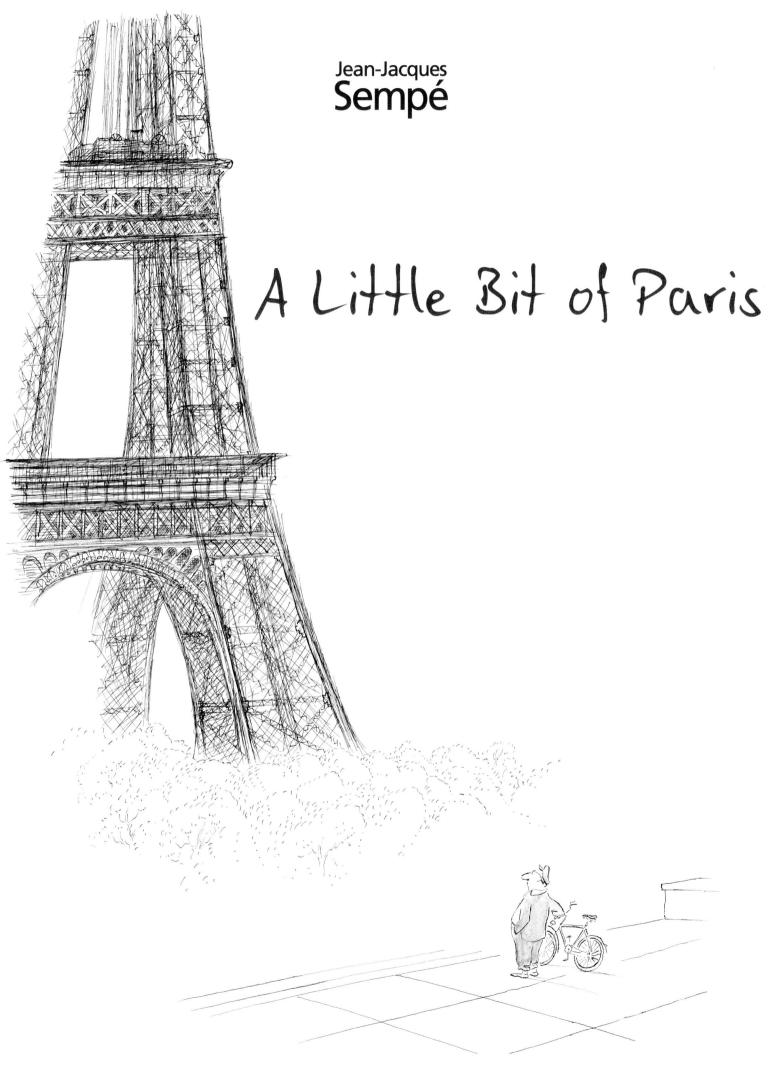

Jean-Jacques
Sempé

A Little Bit of Paris

Universe

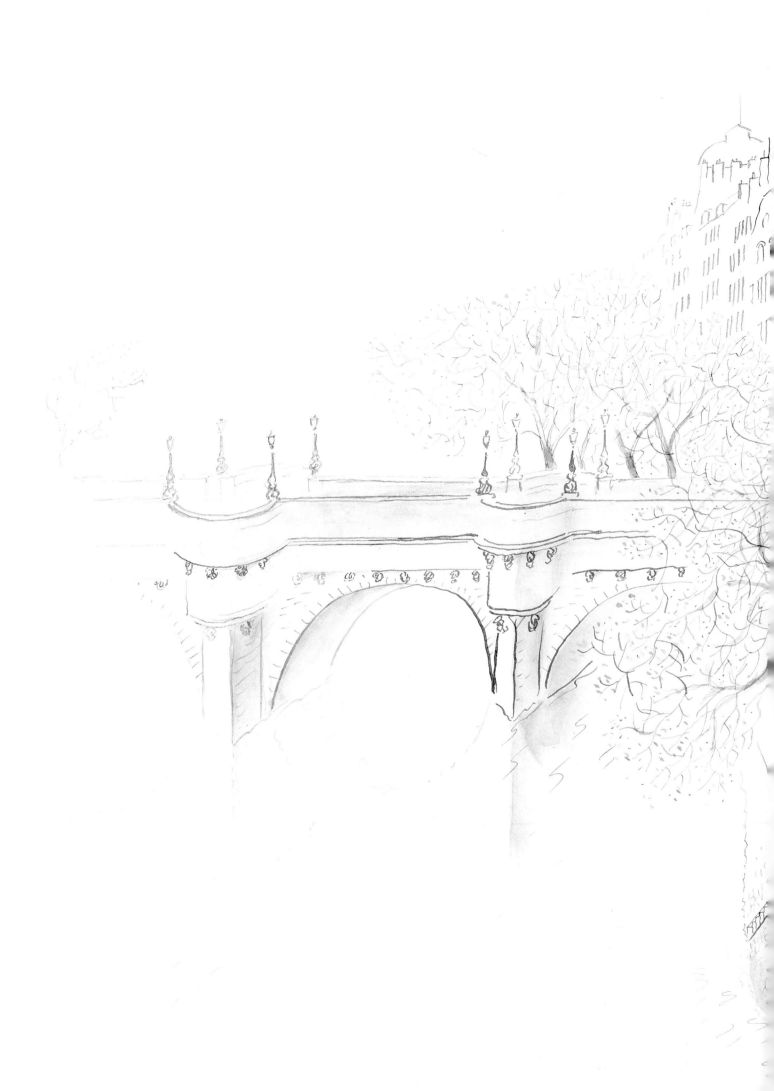

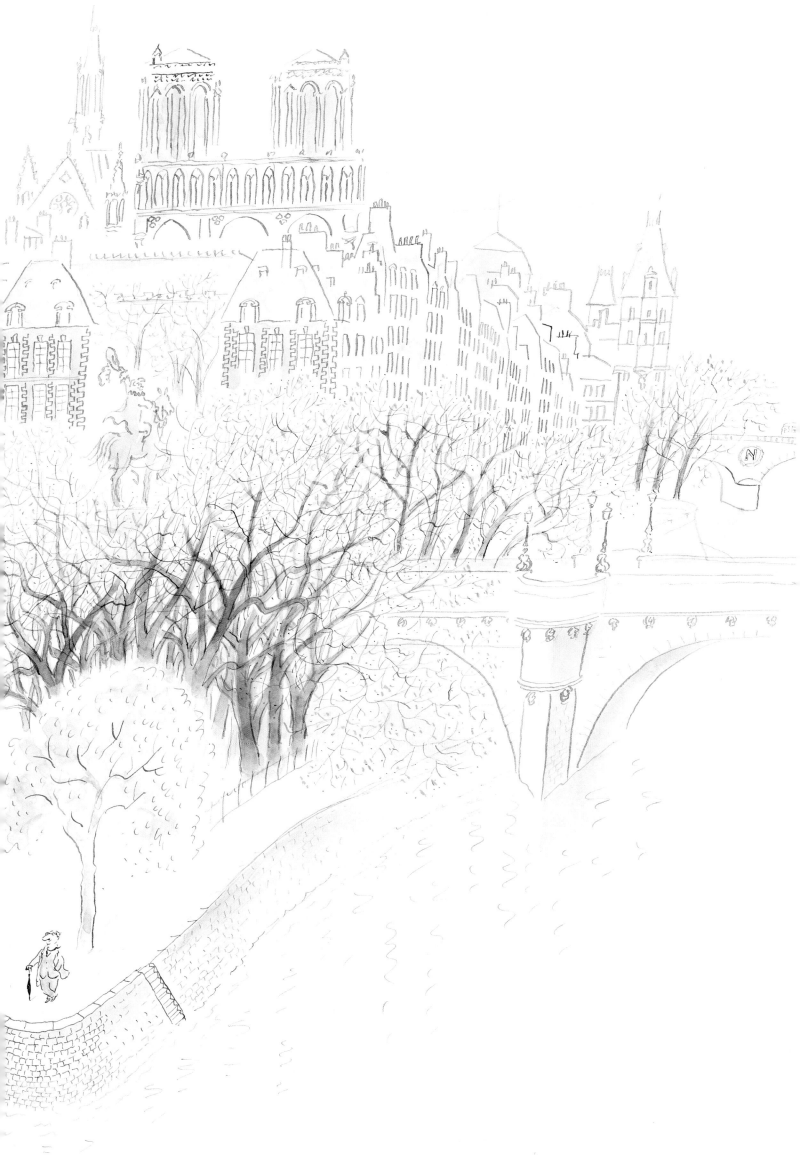

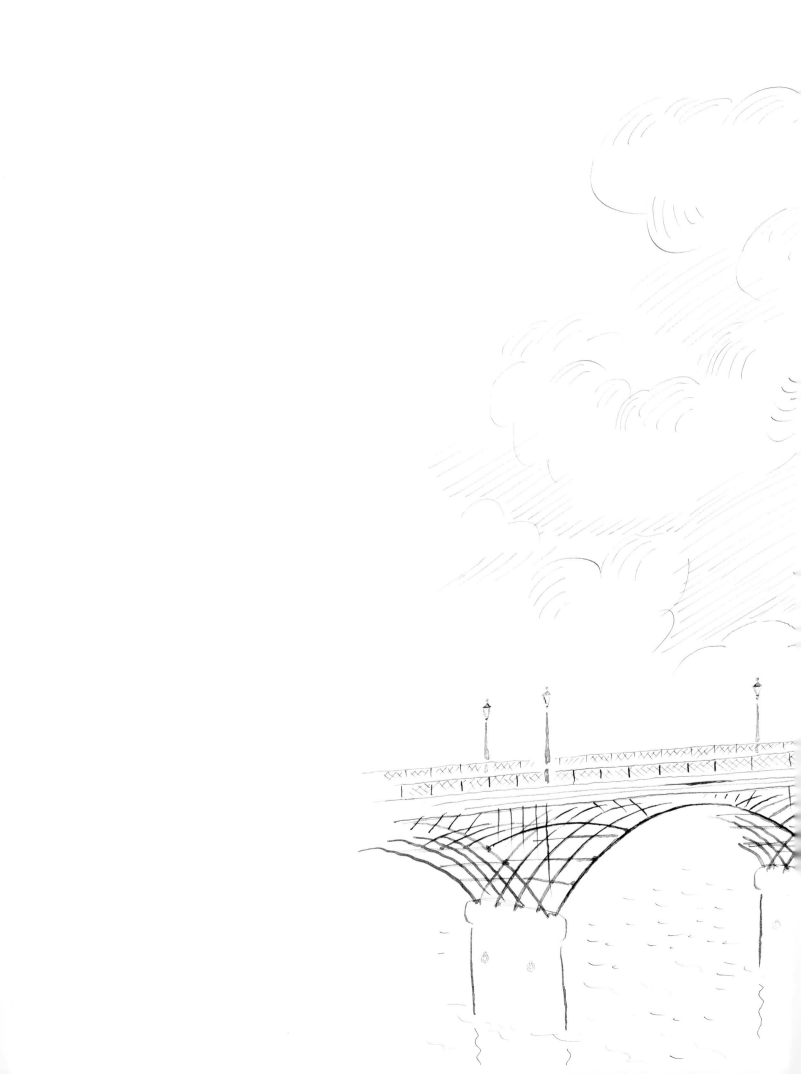

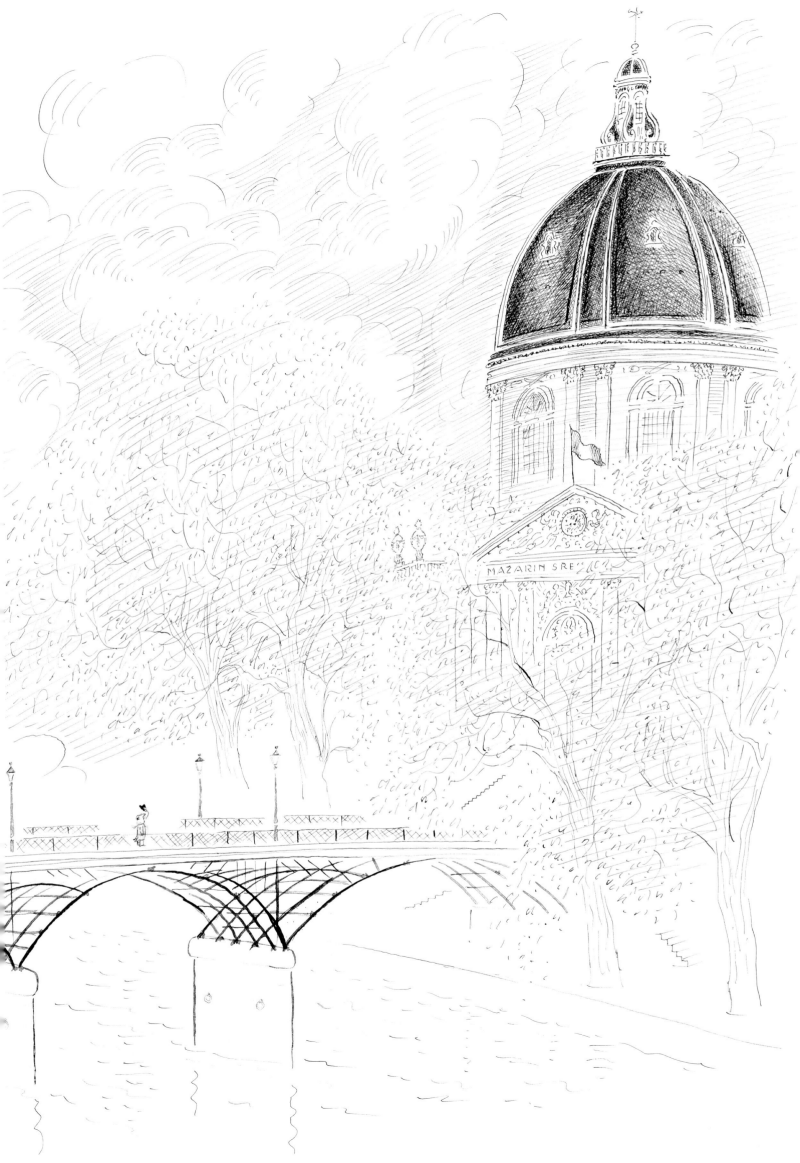

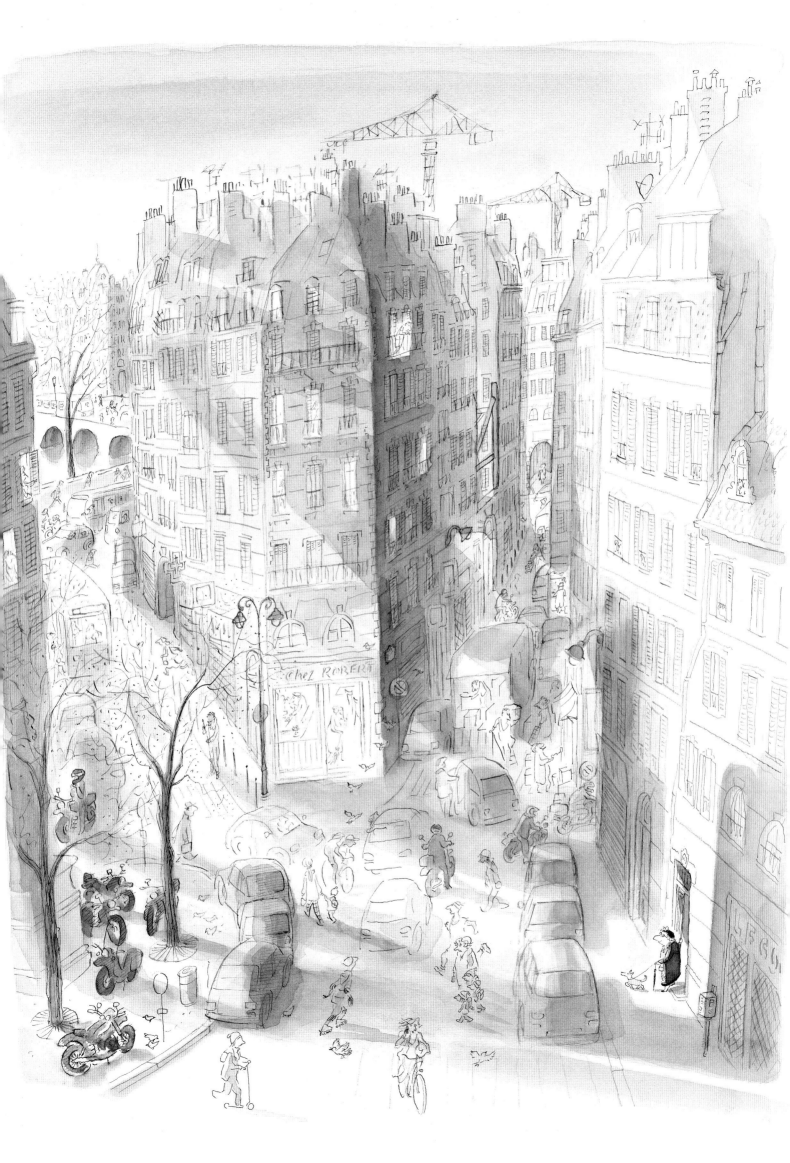

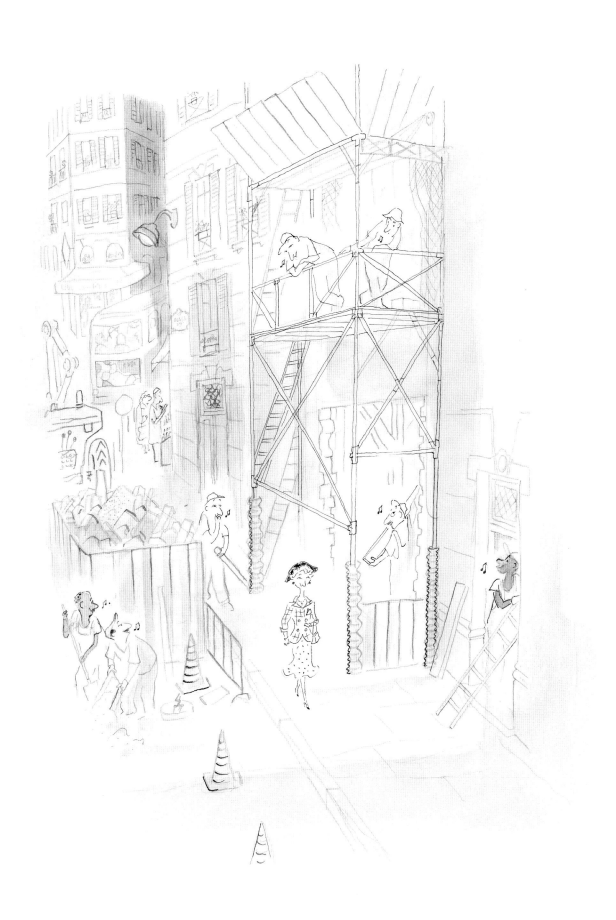

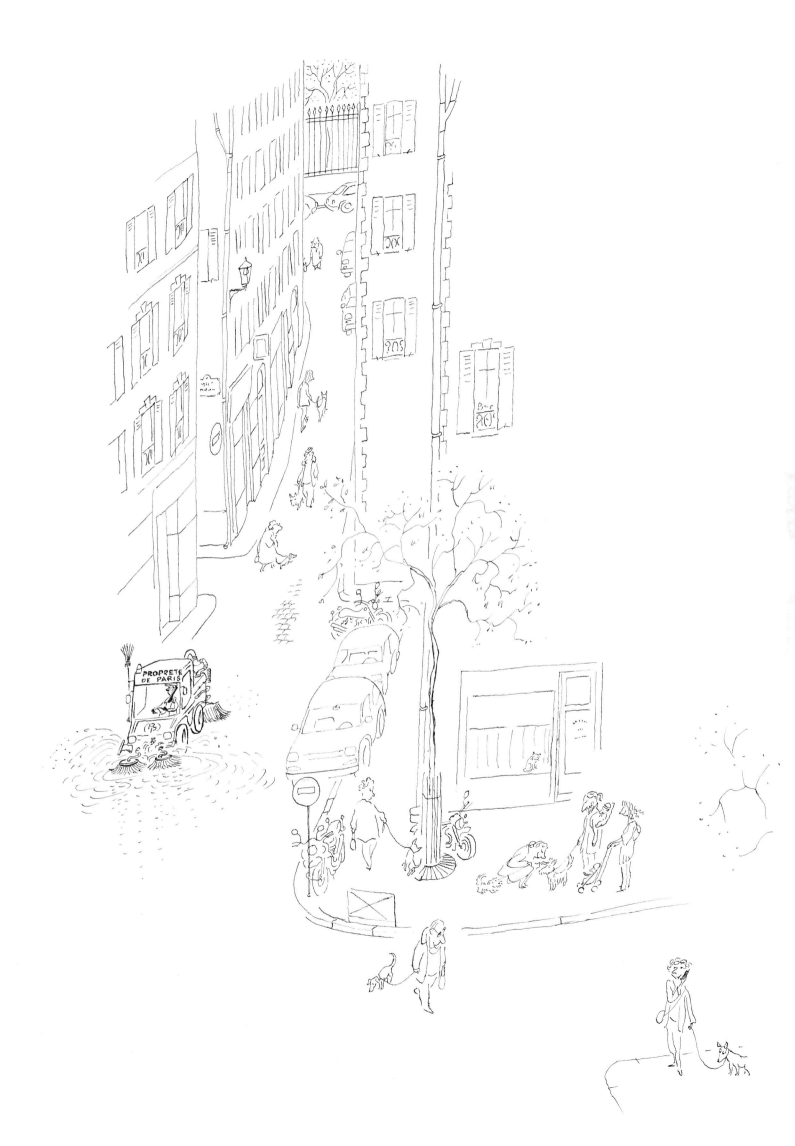

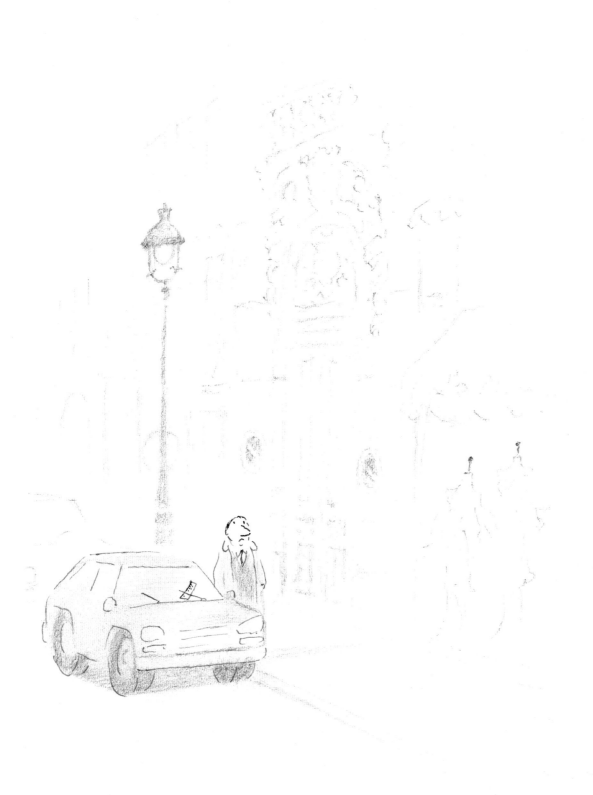

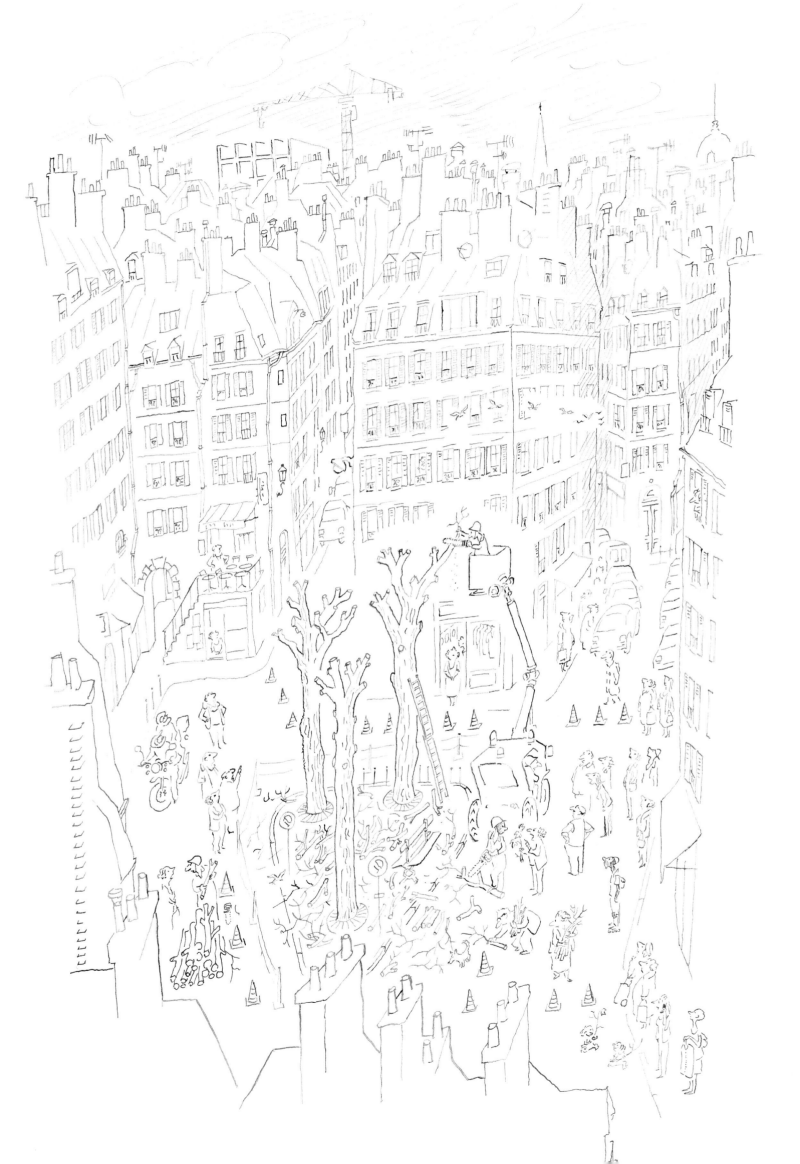

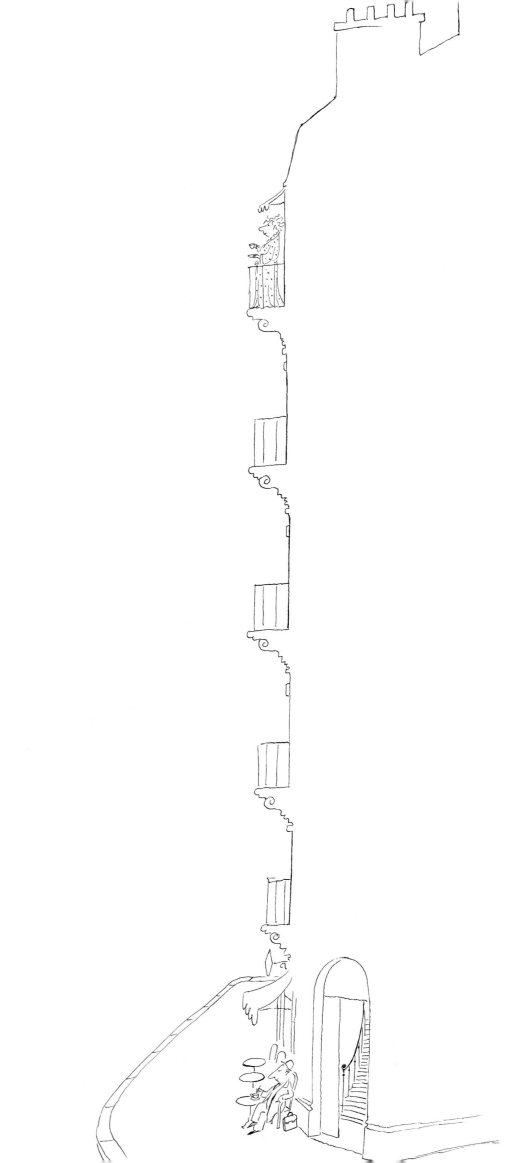

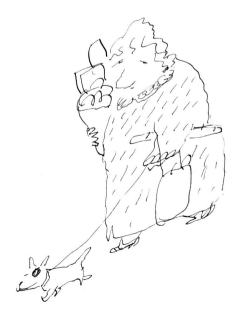

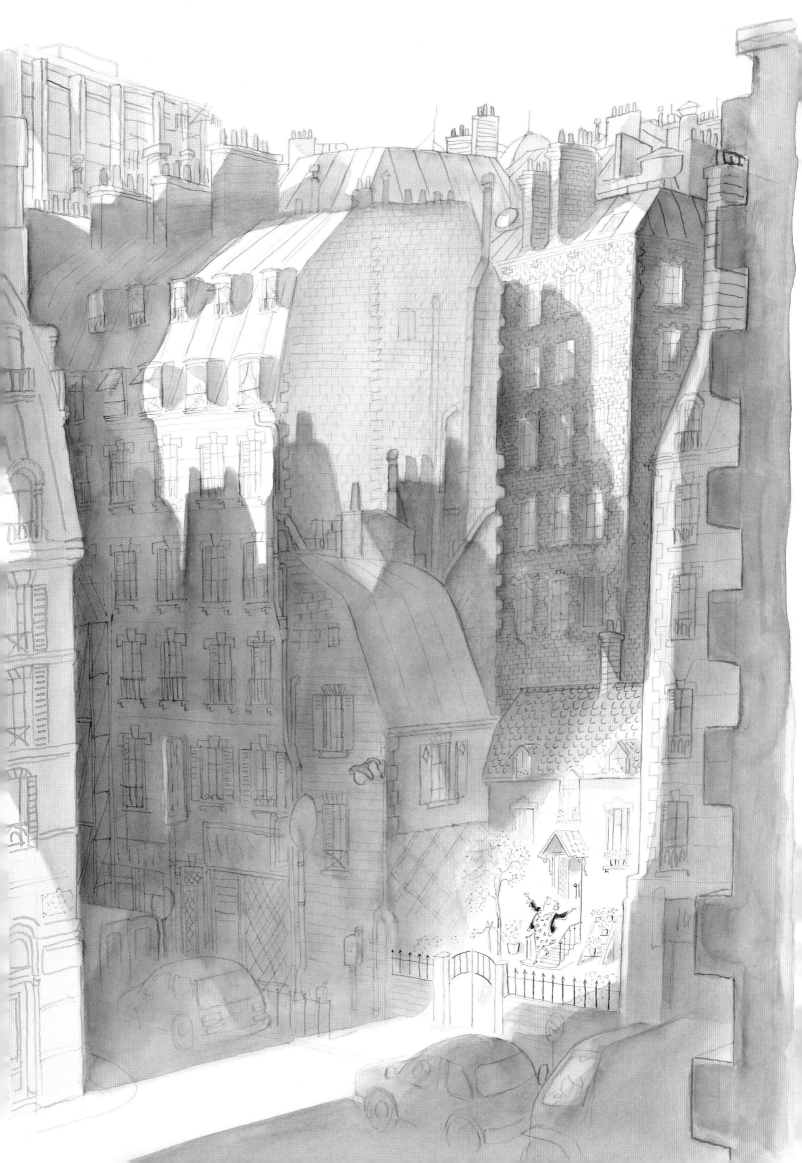

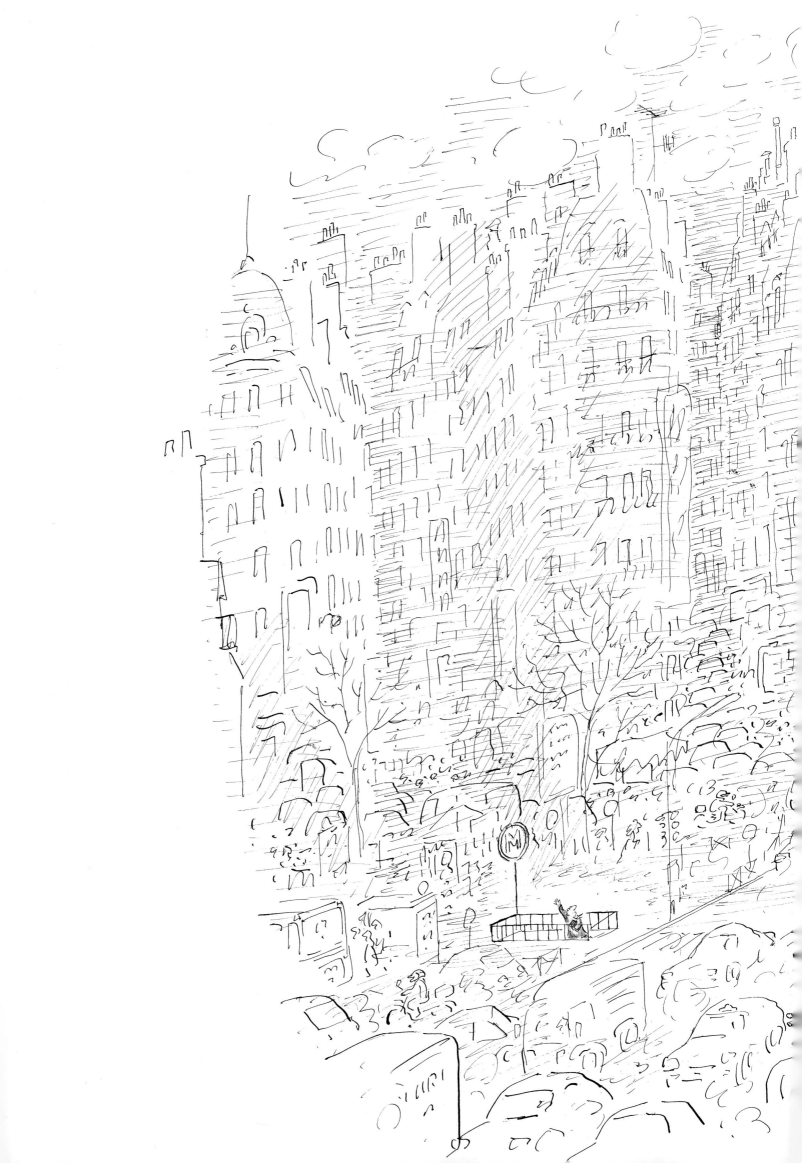

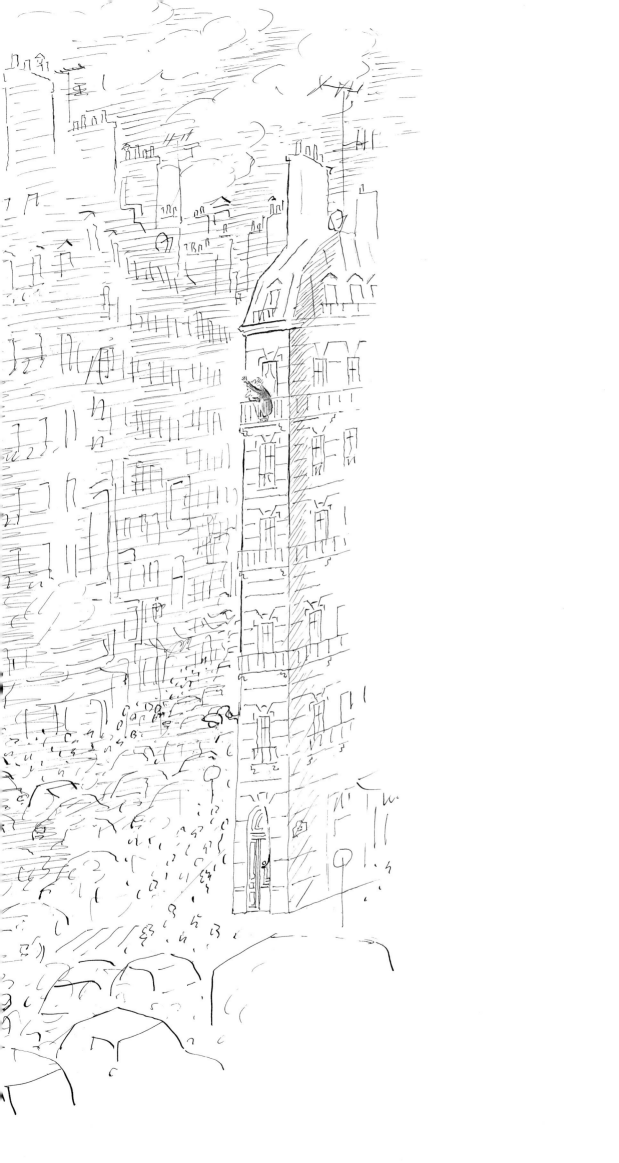

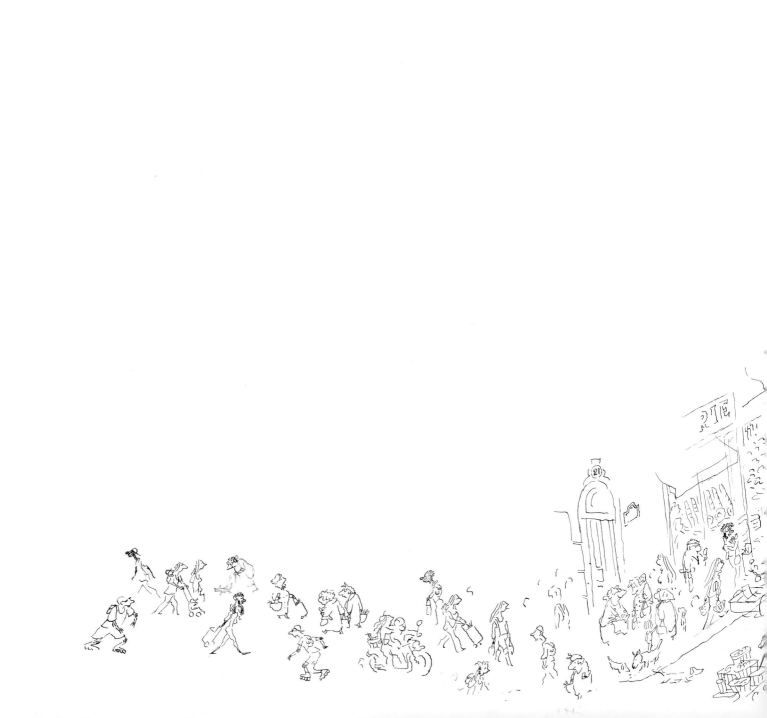

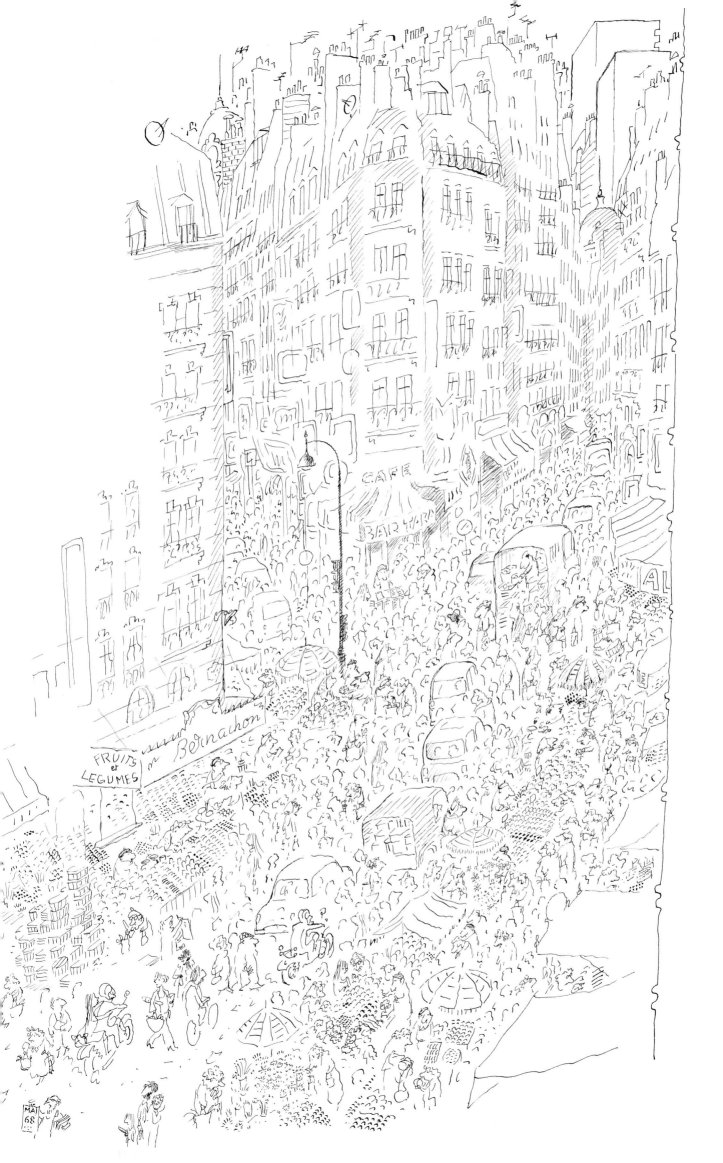

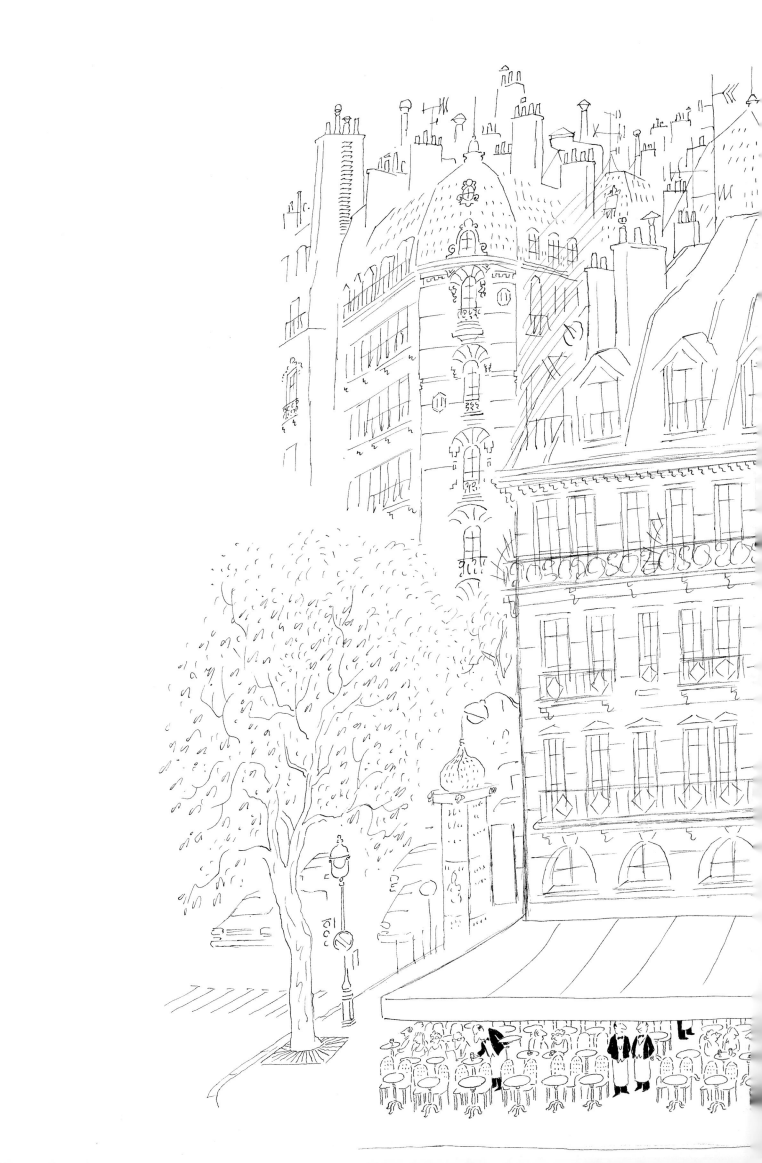

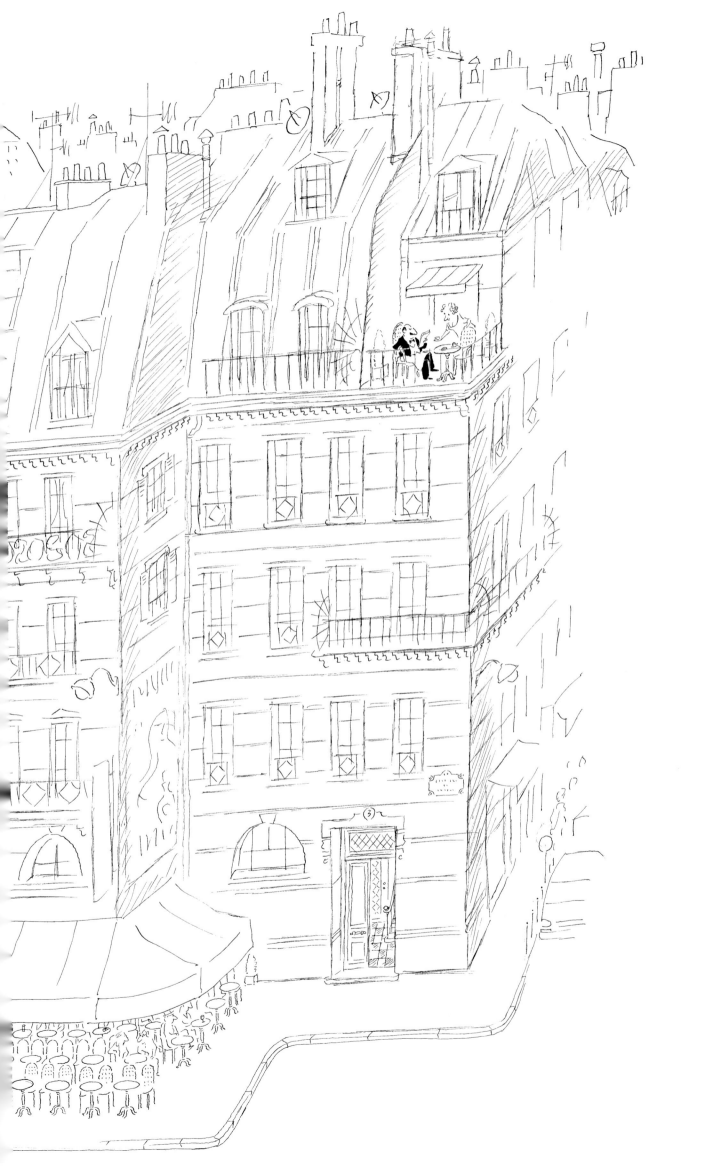

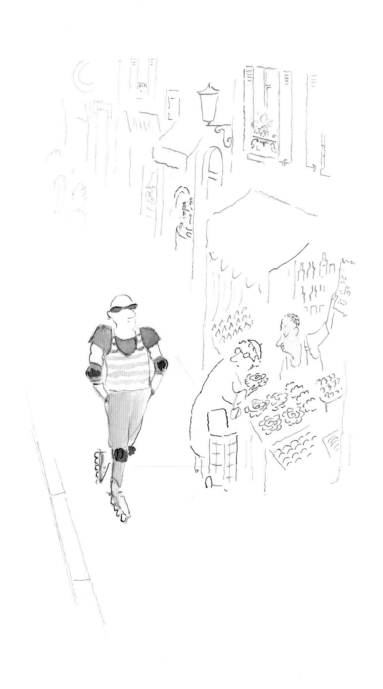

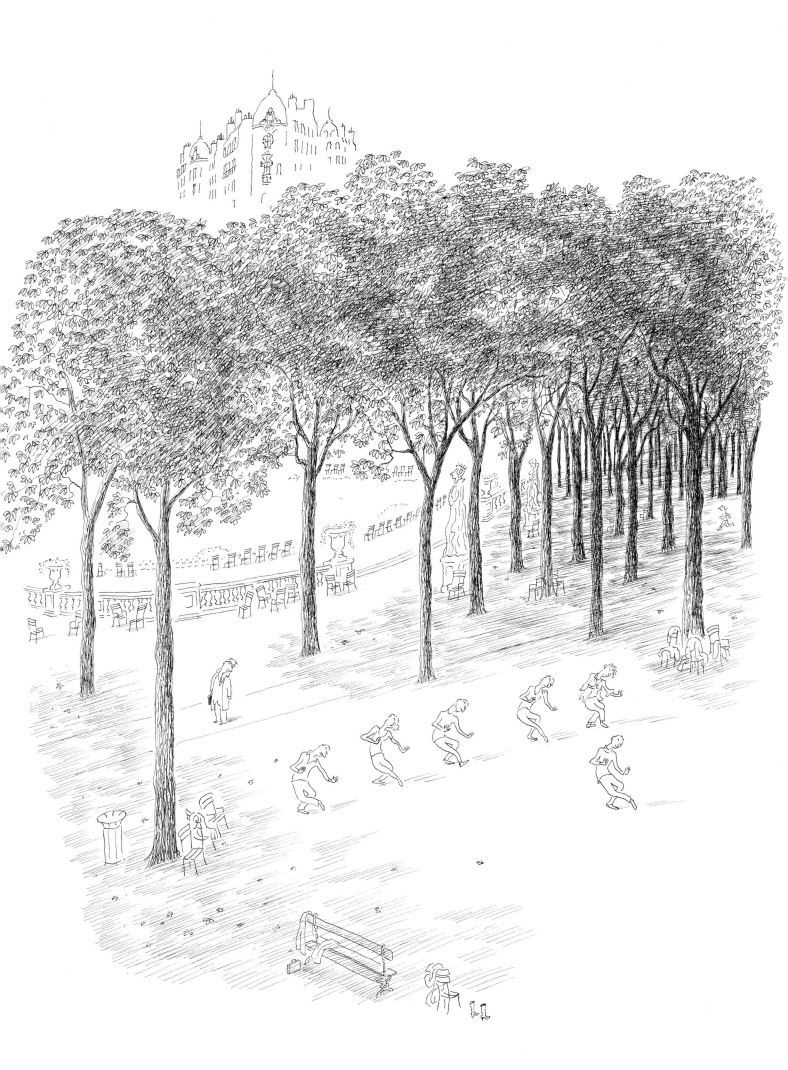

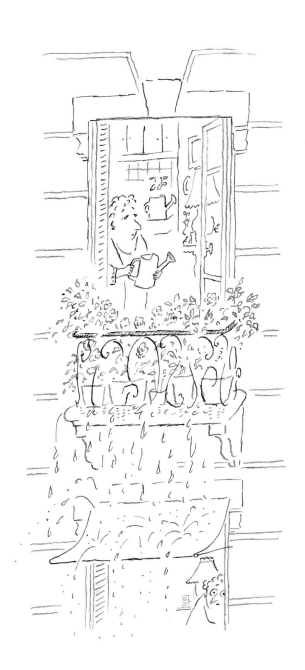

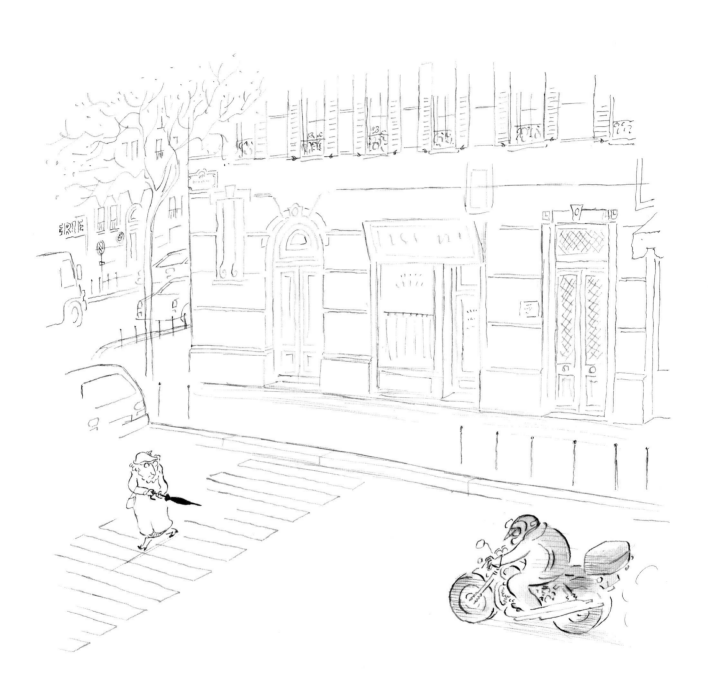

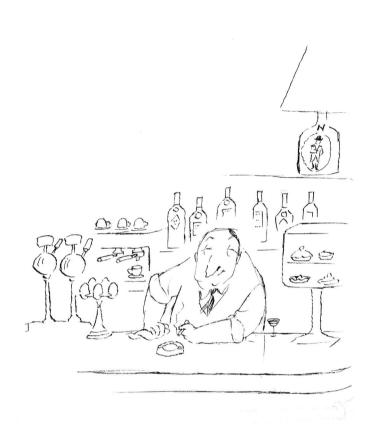

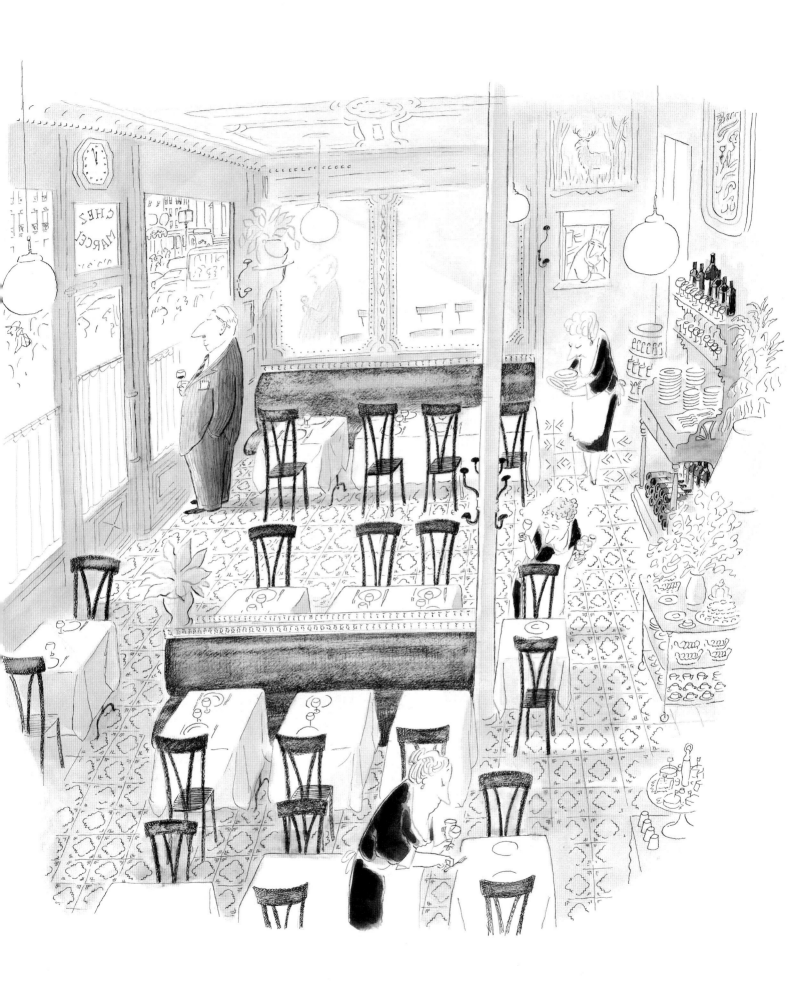

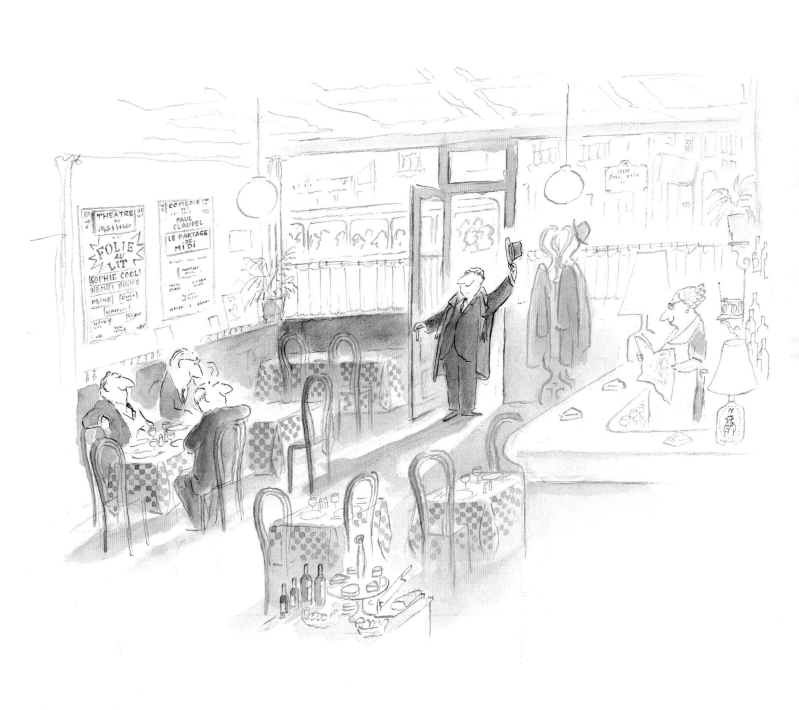

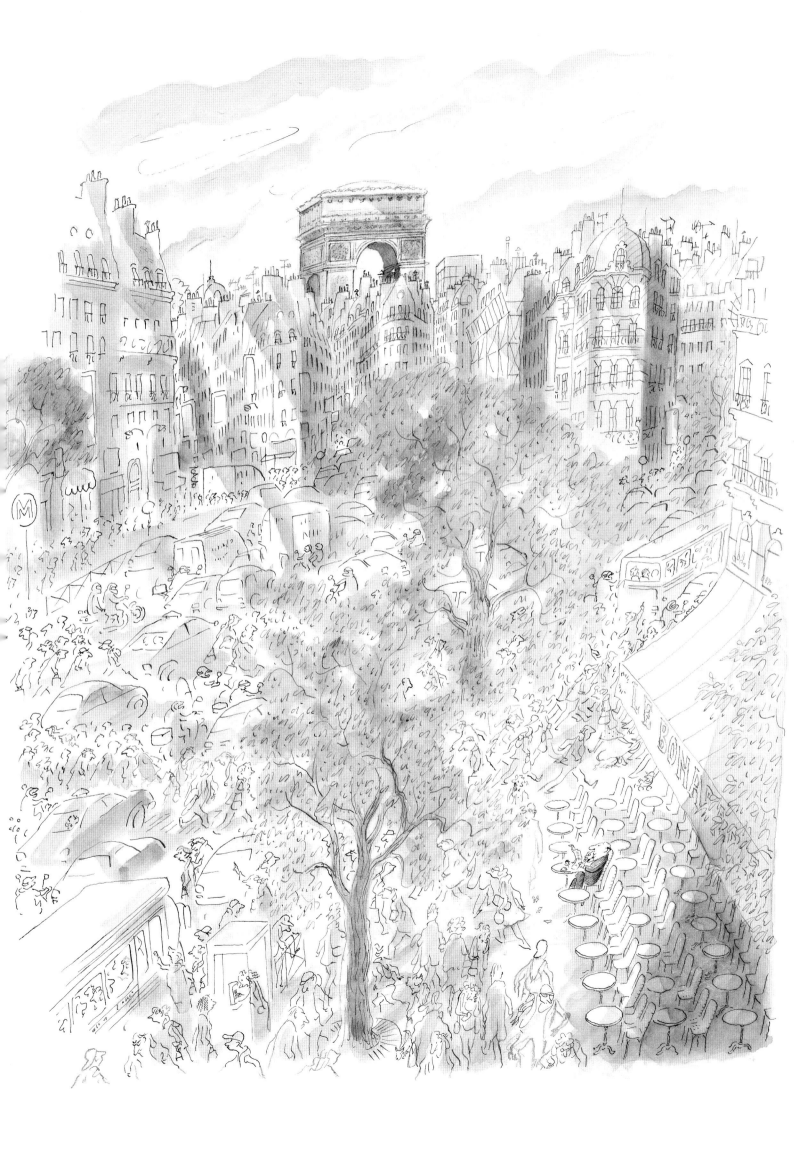

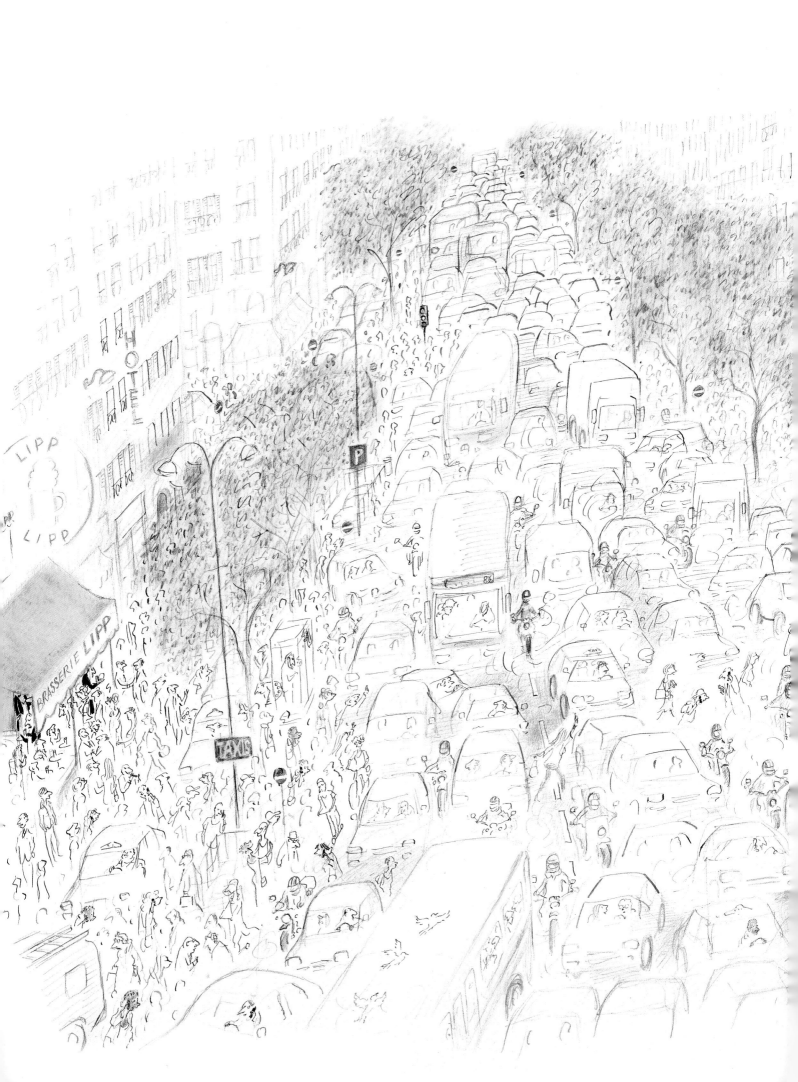

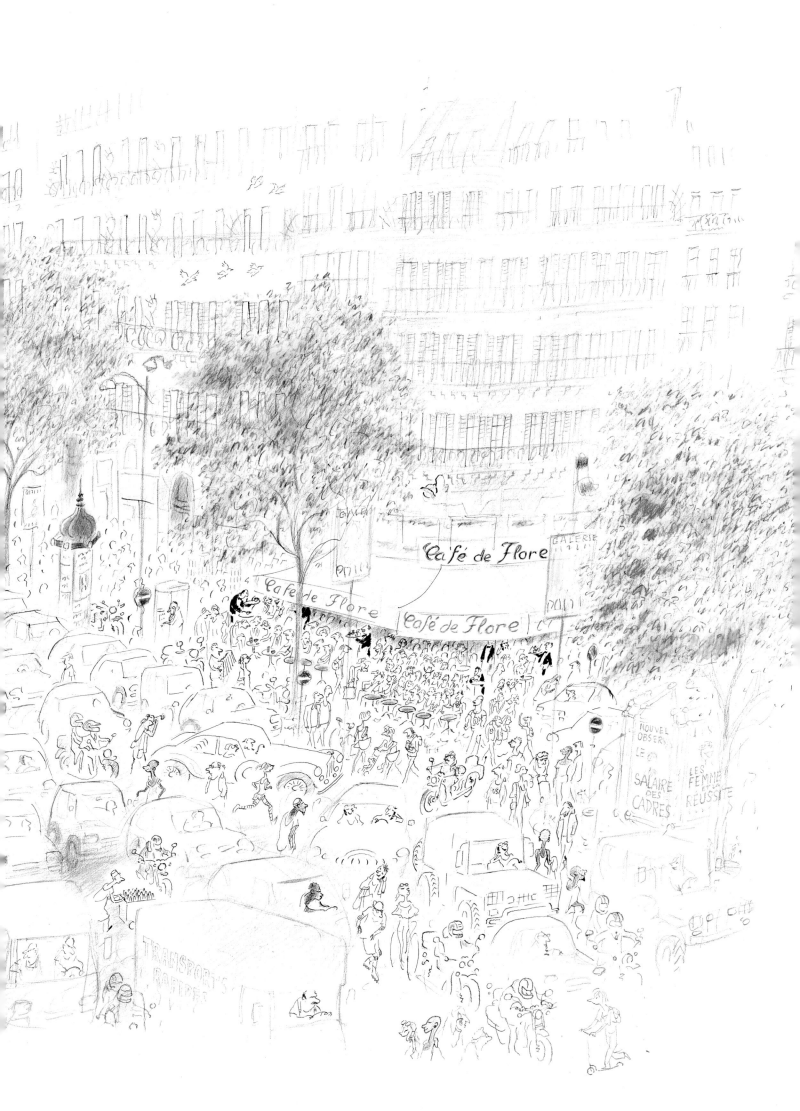

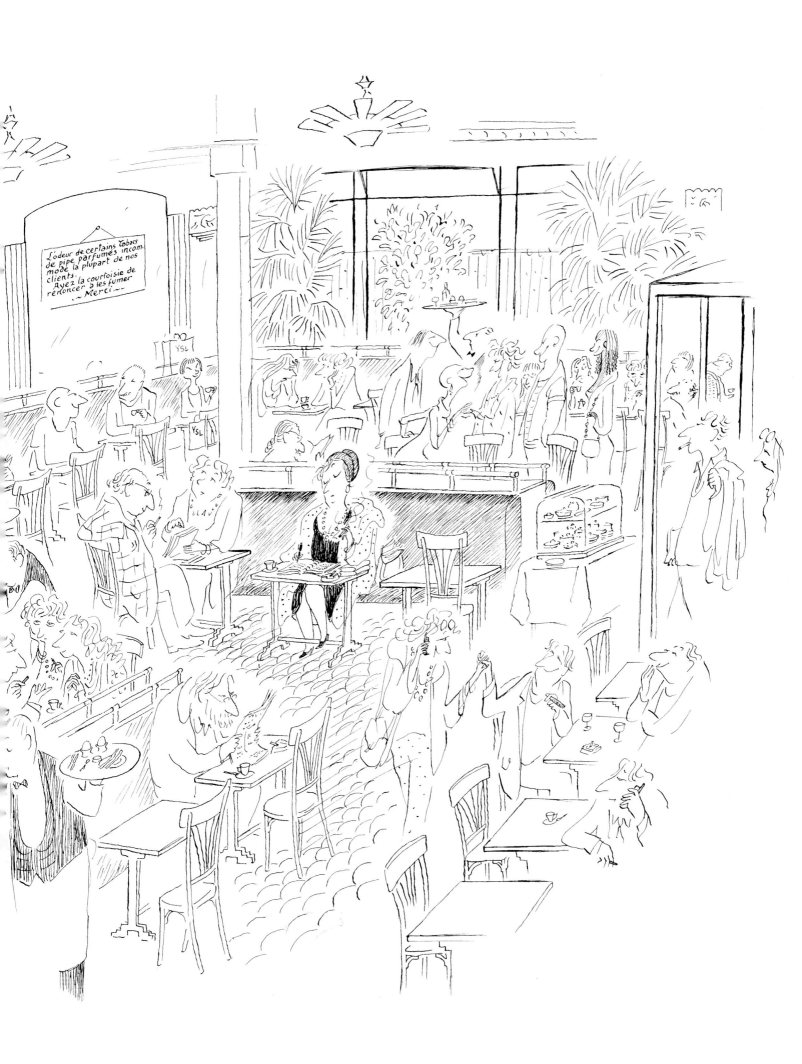

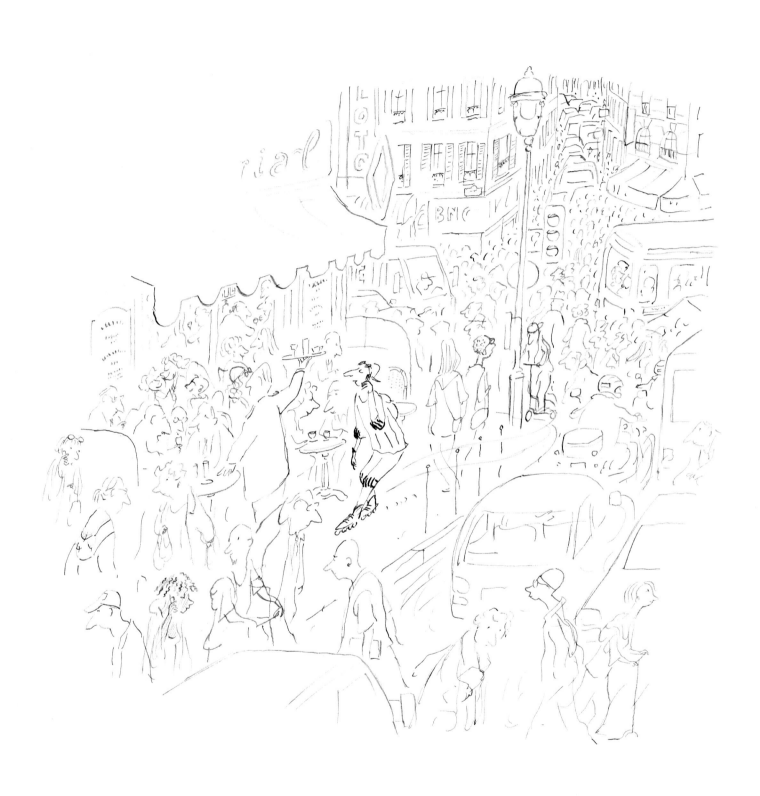

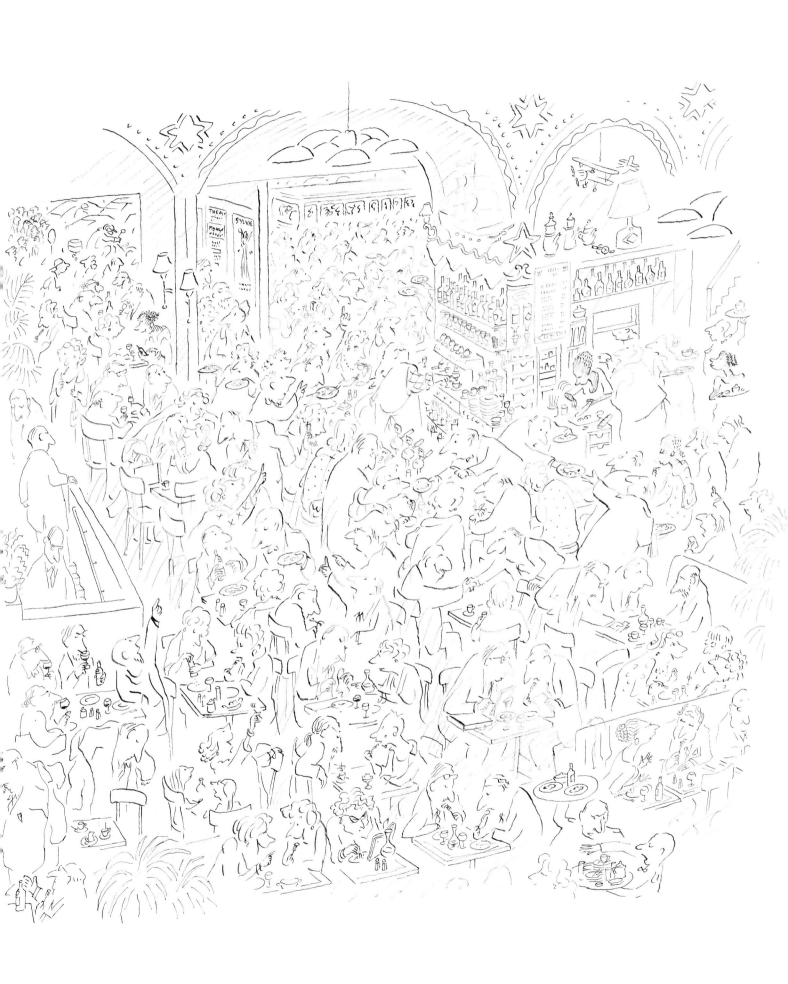

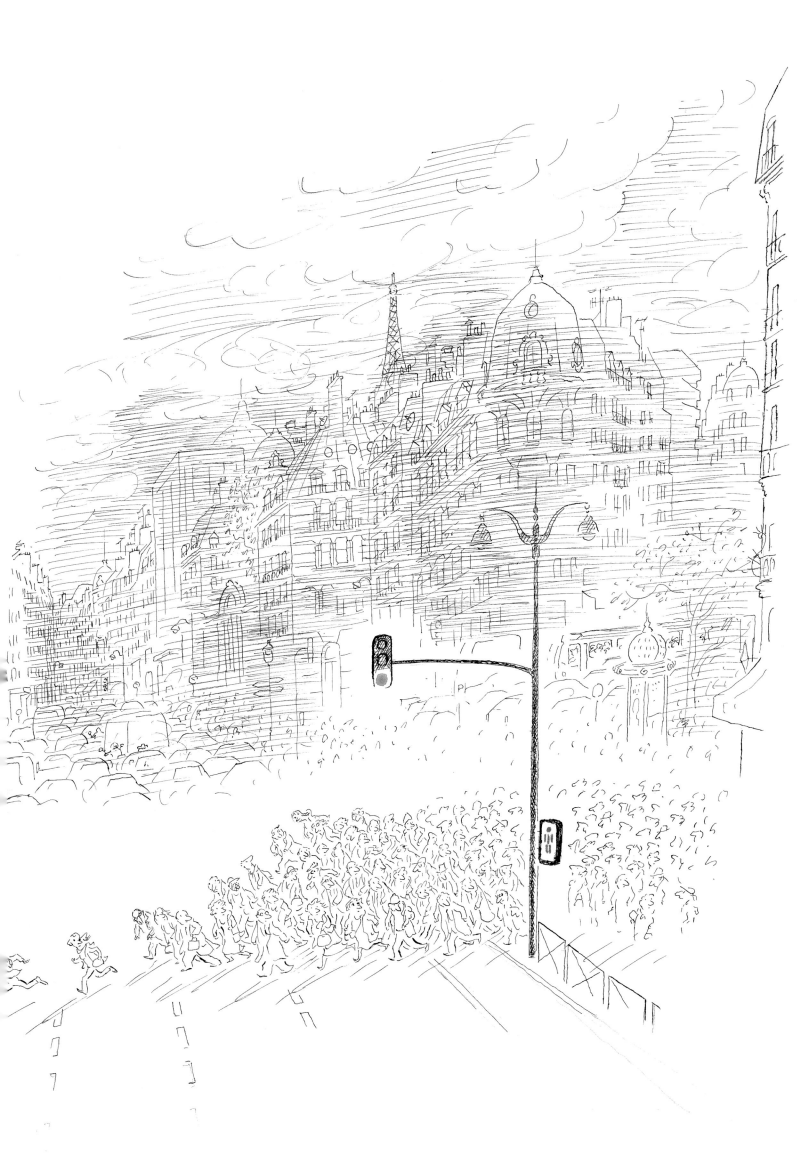

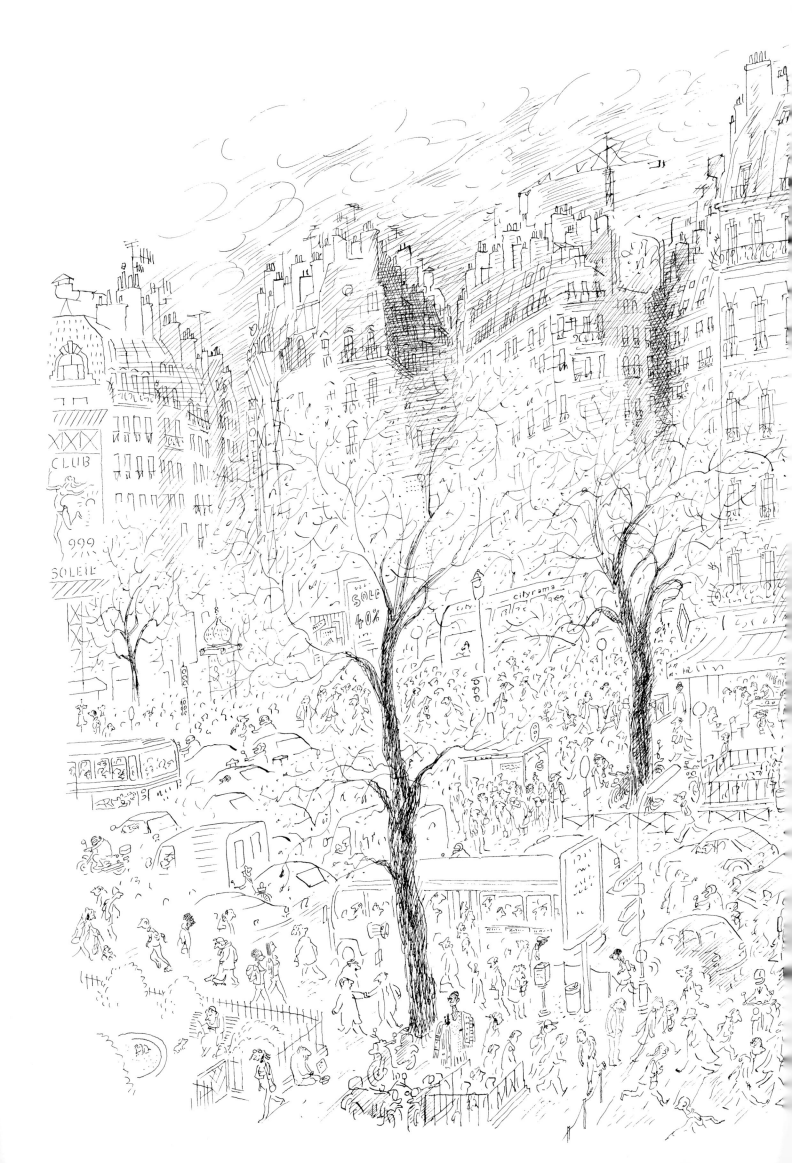

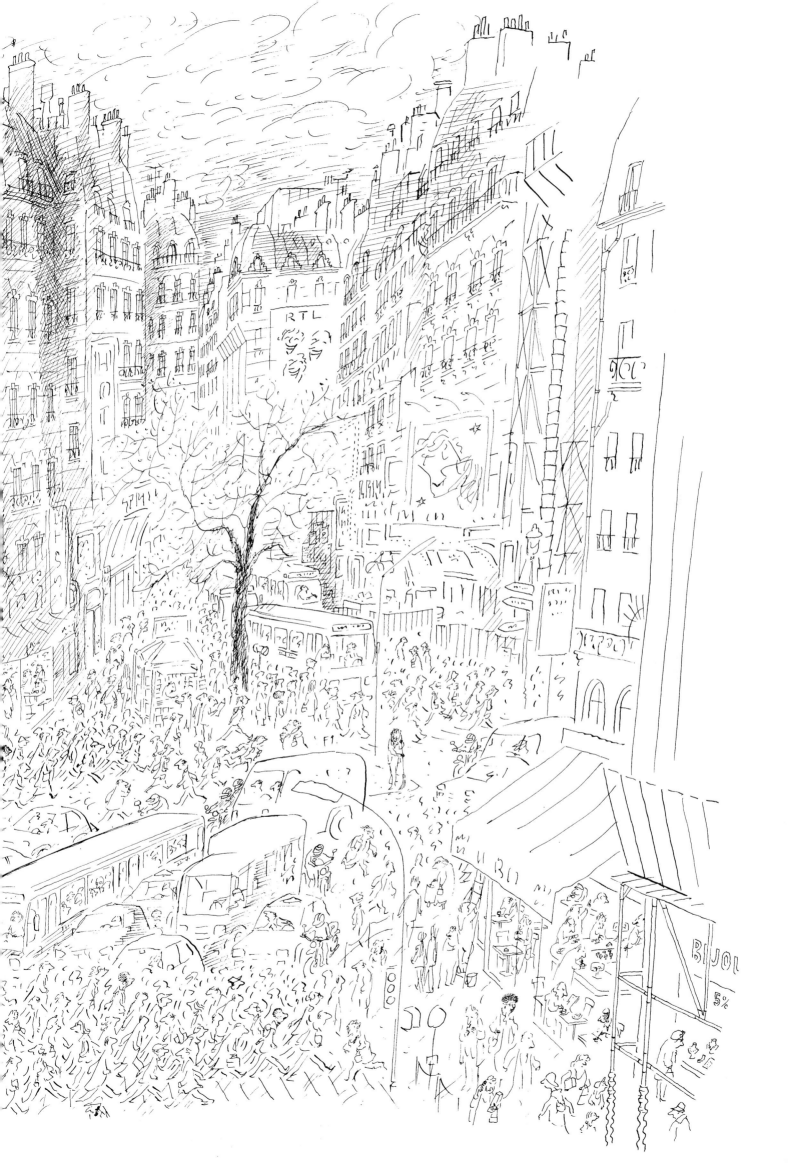

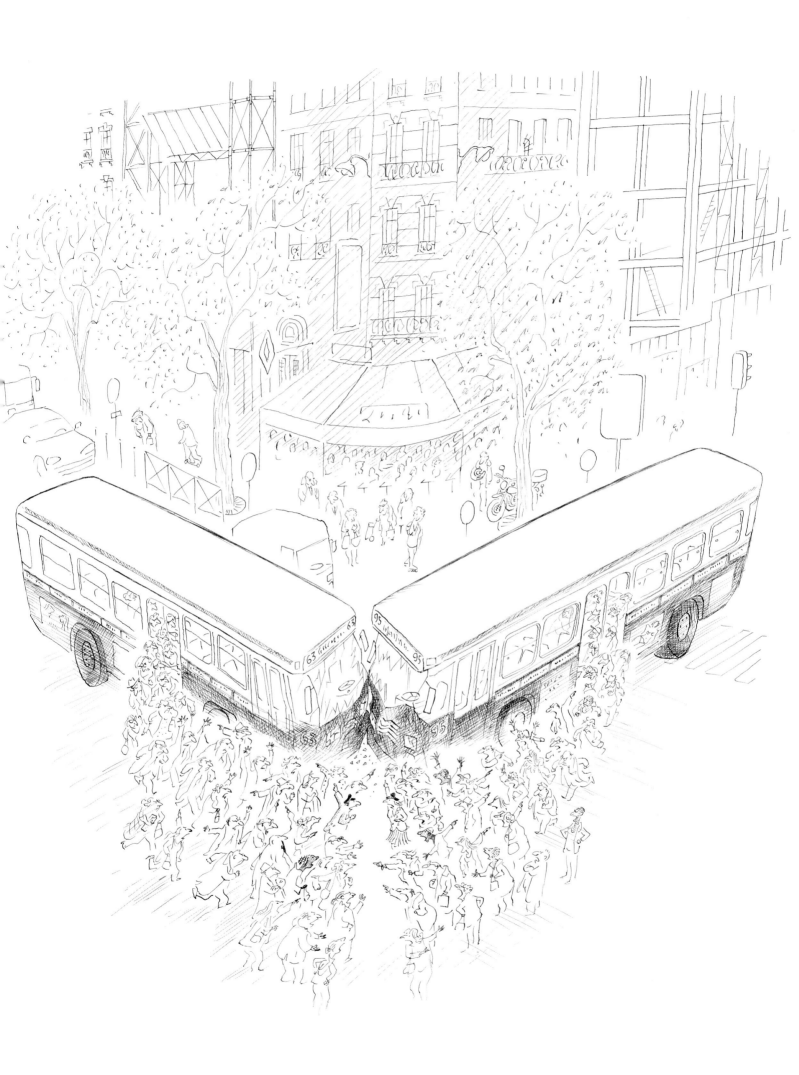

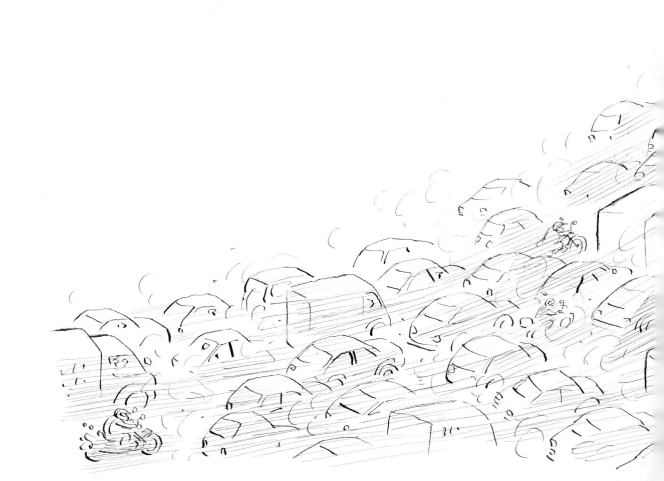

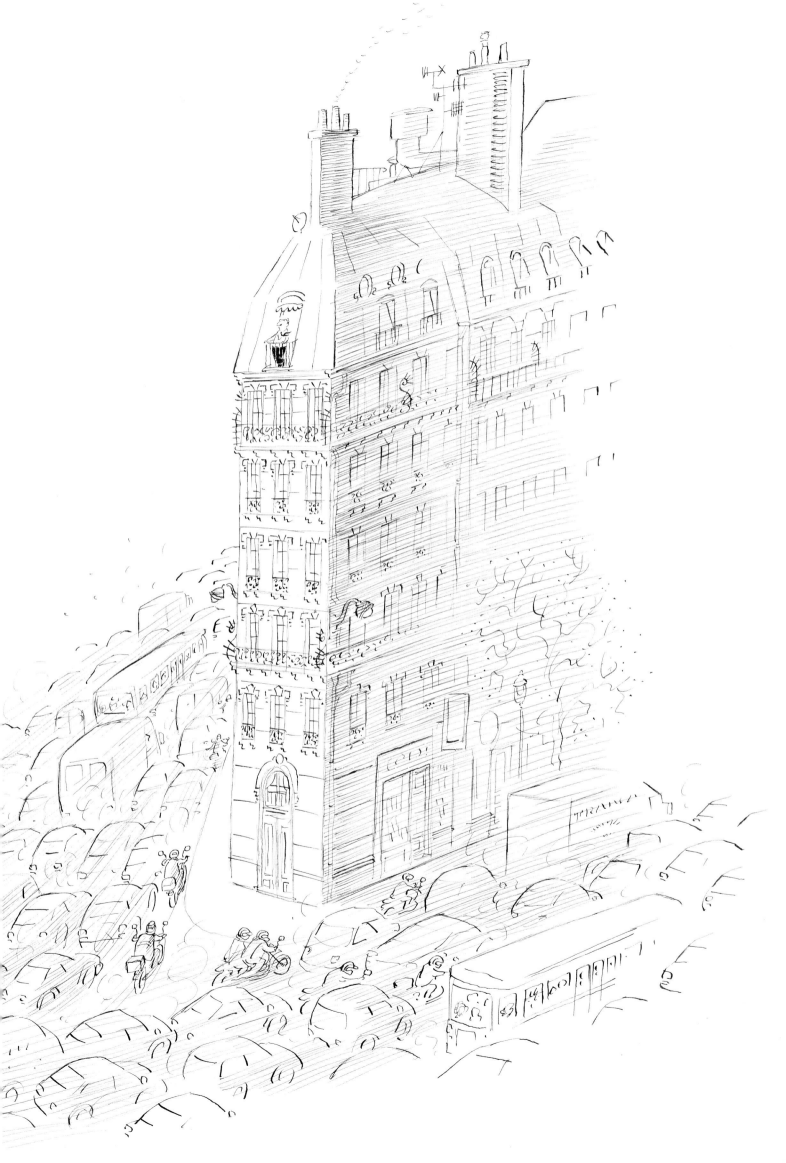

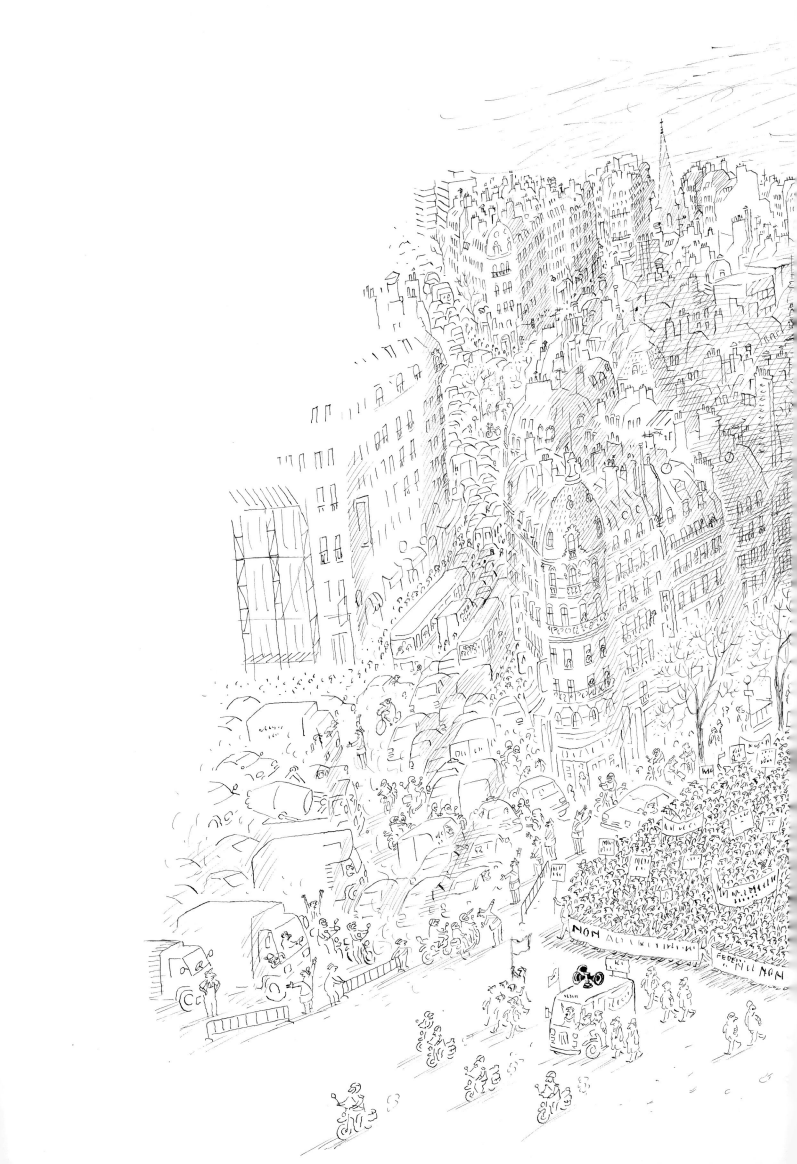

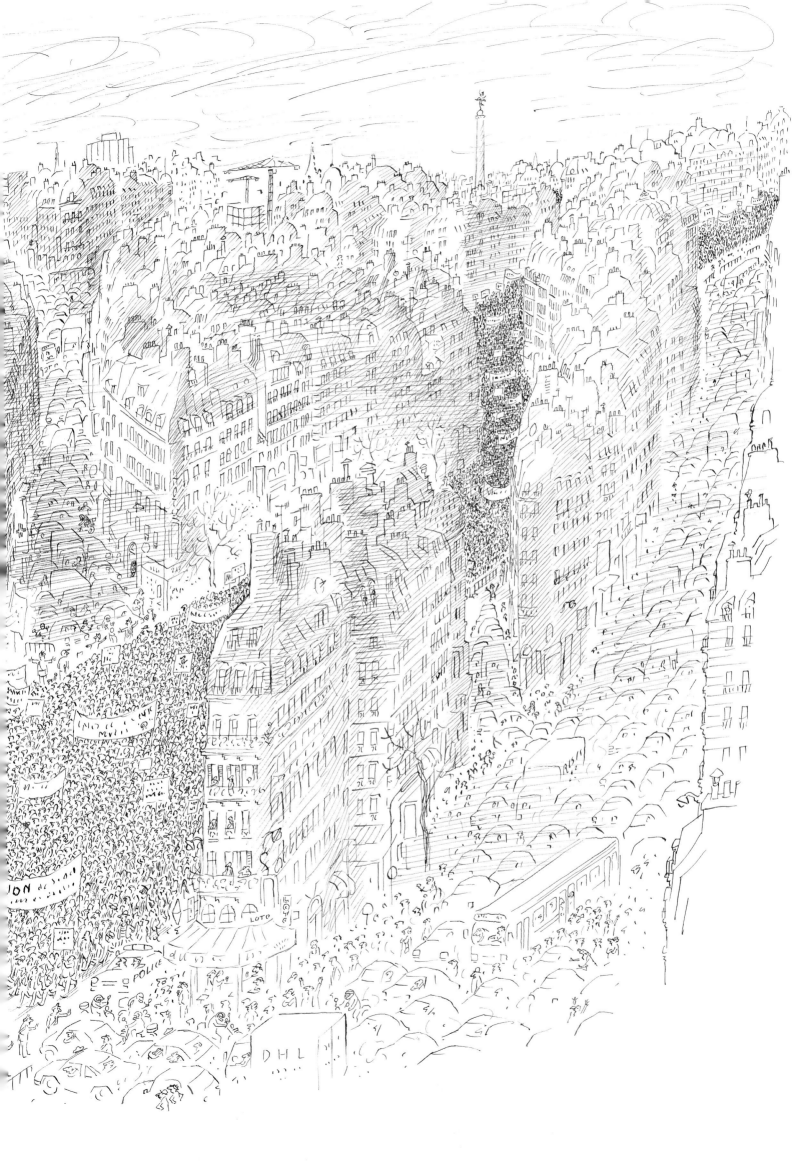

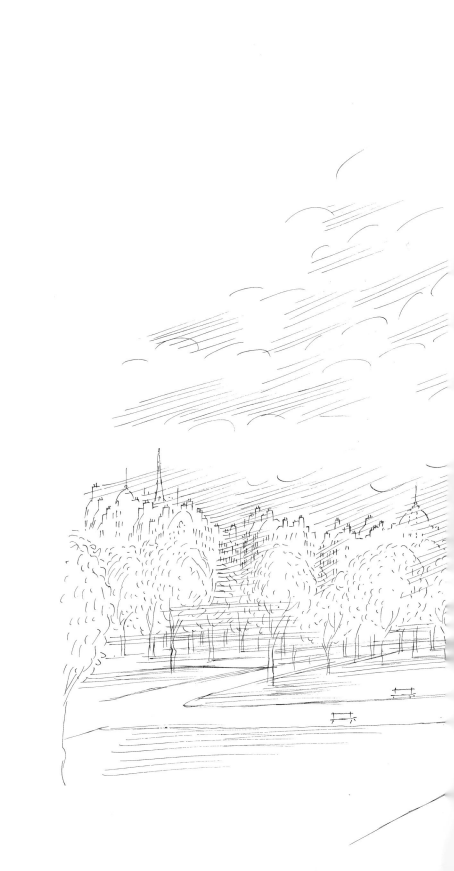

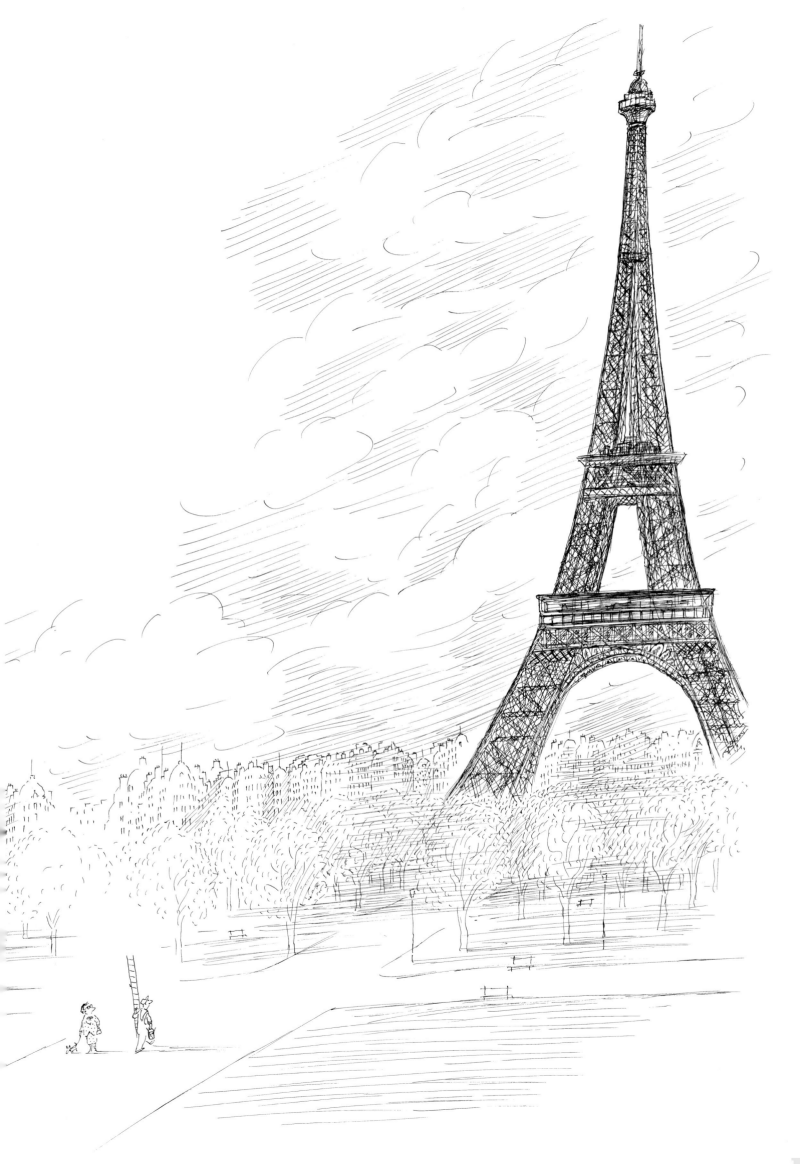

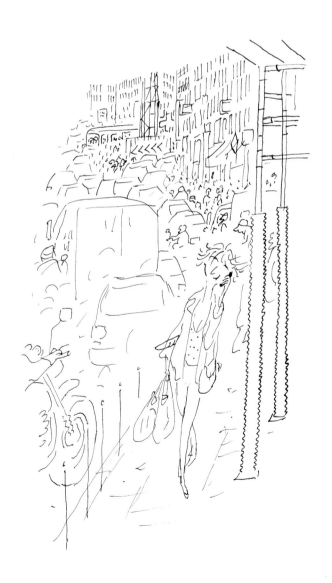

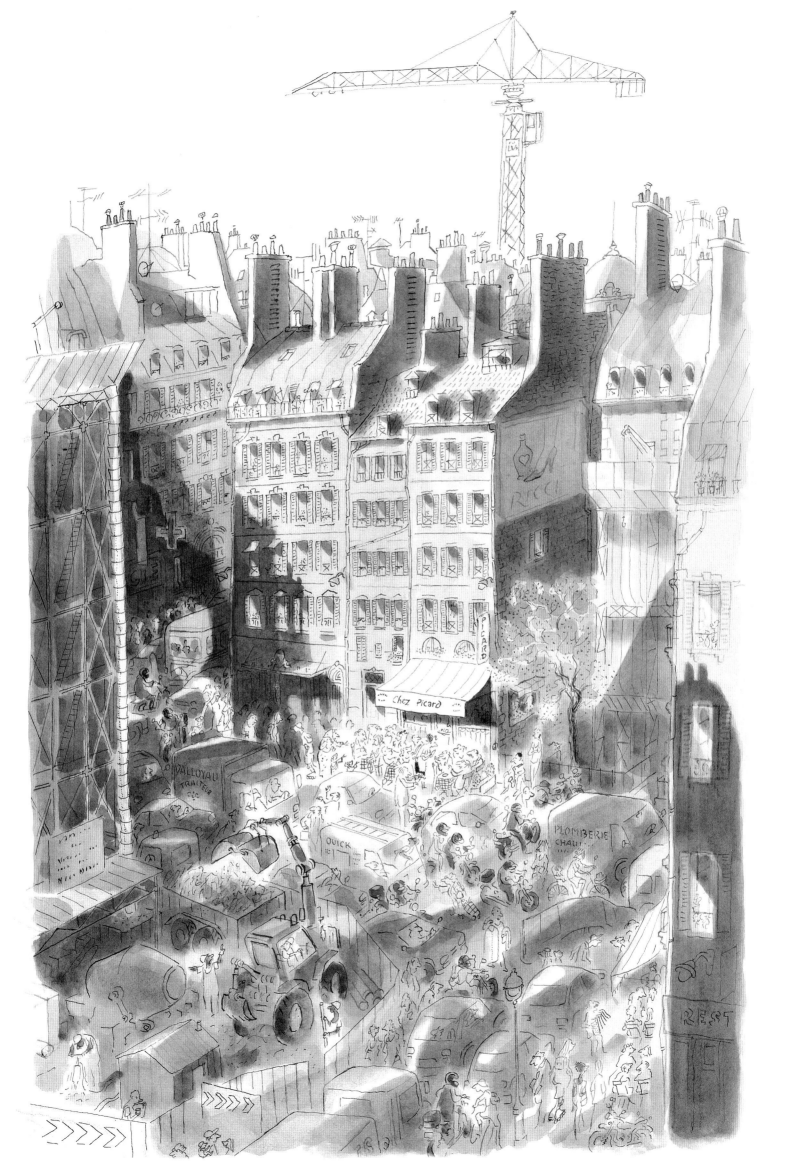

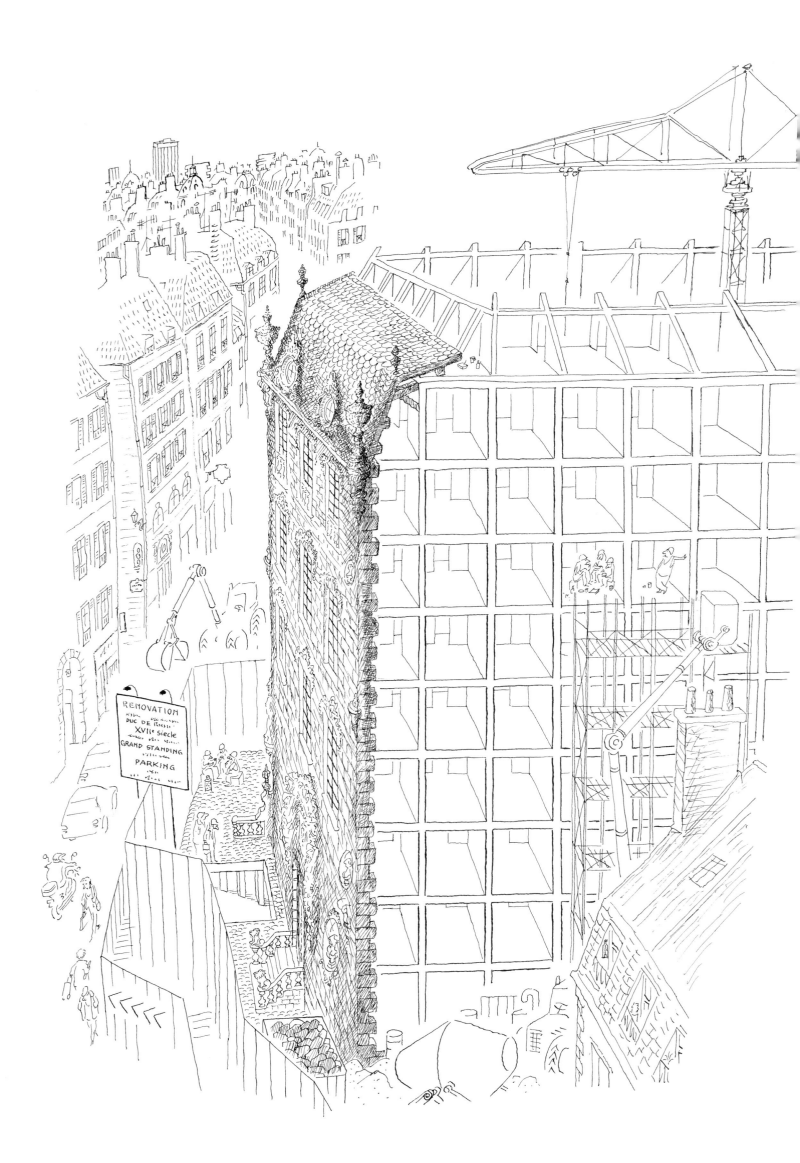

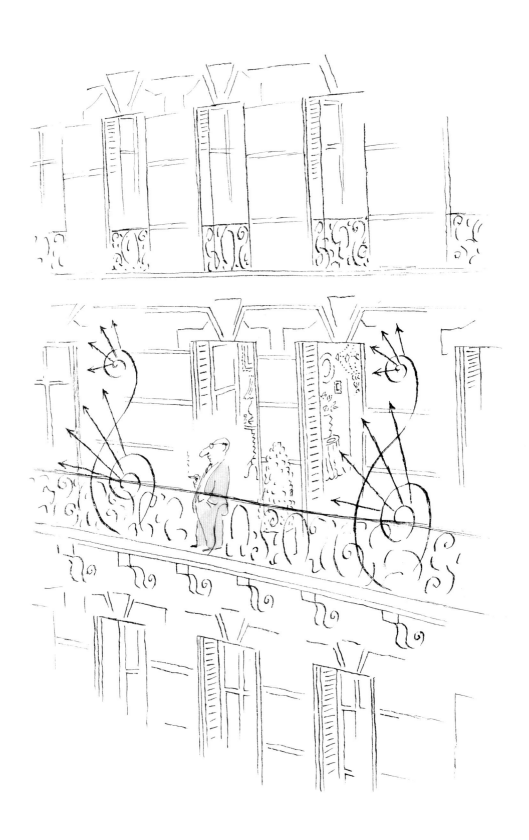

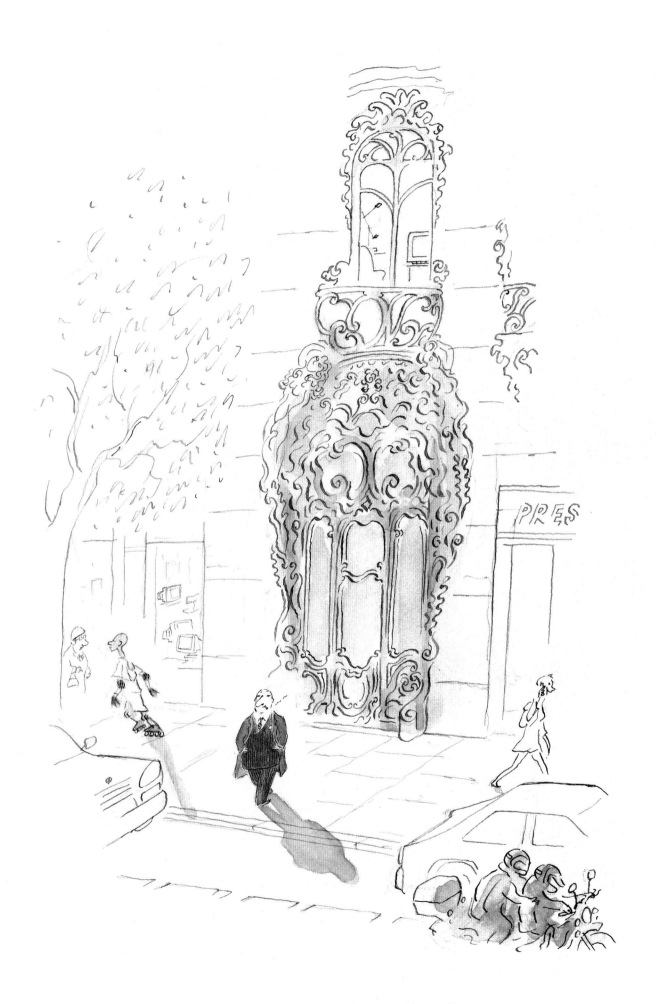

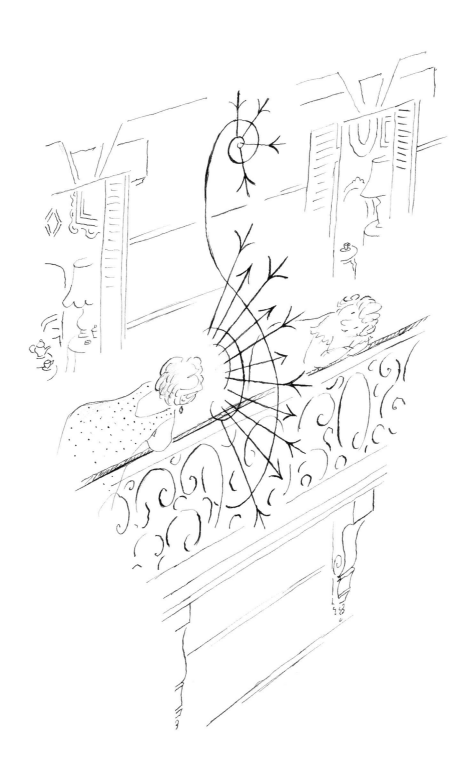

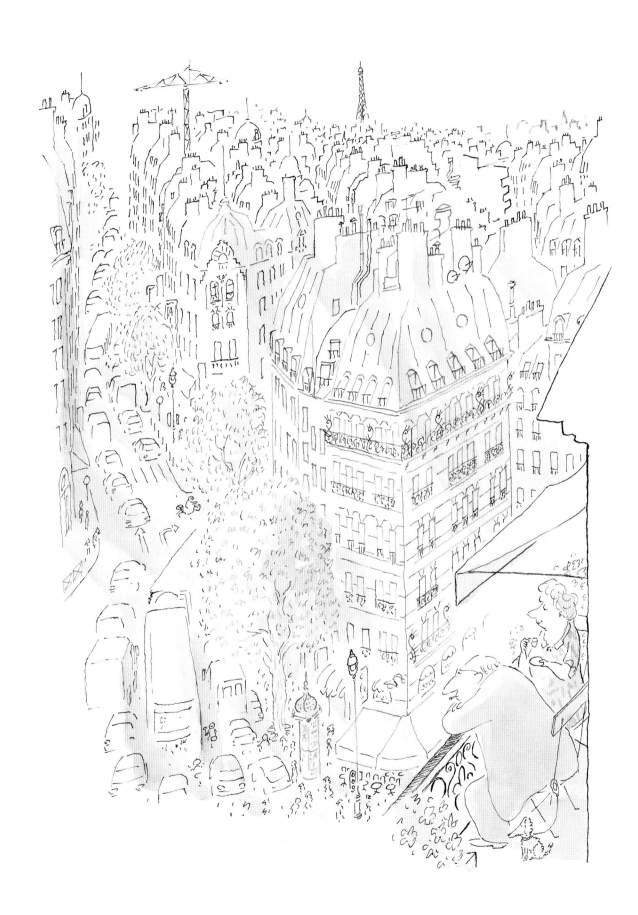

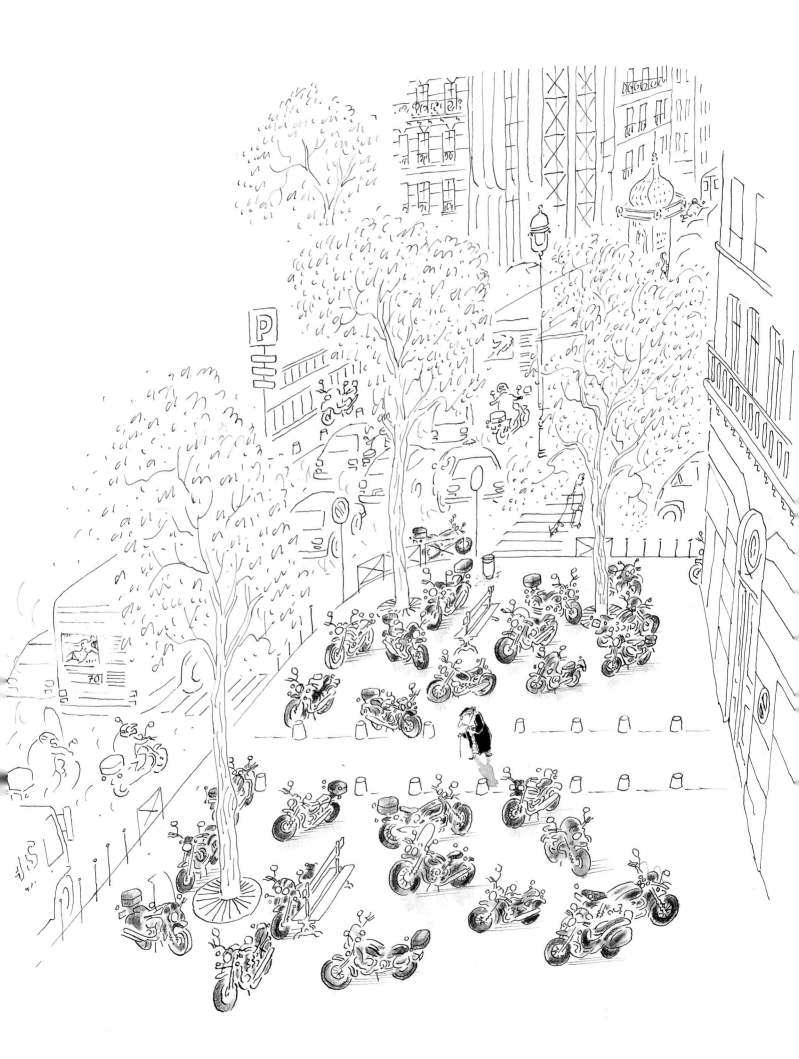

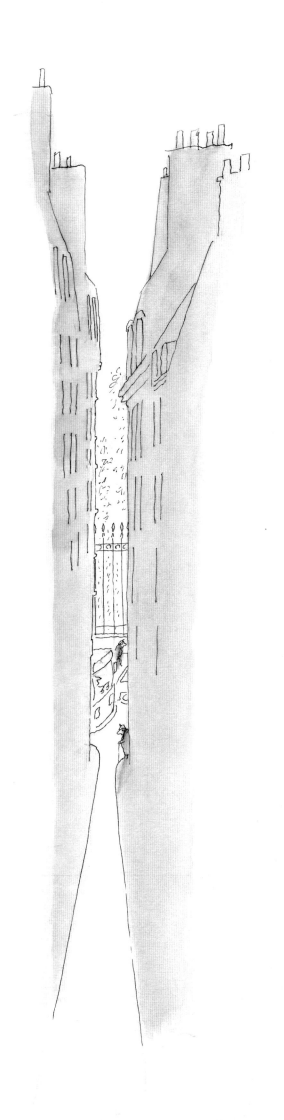

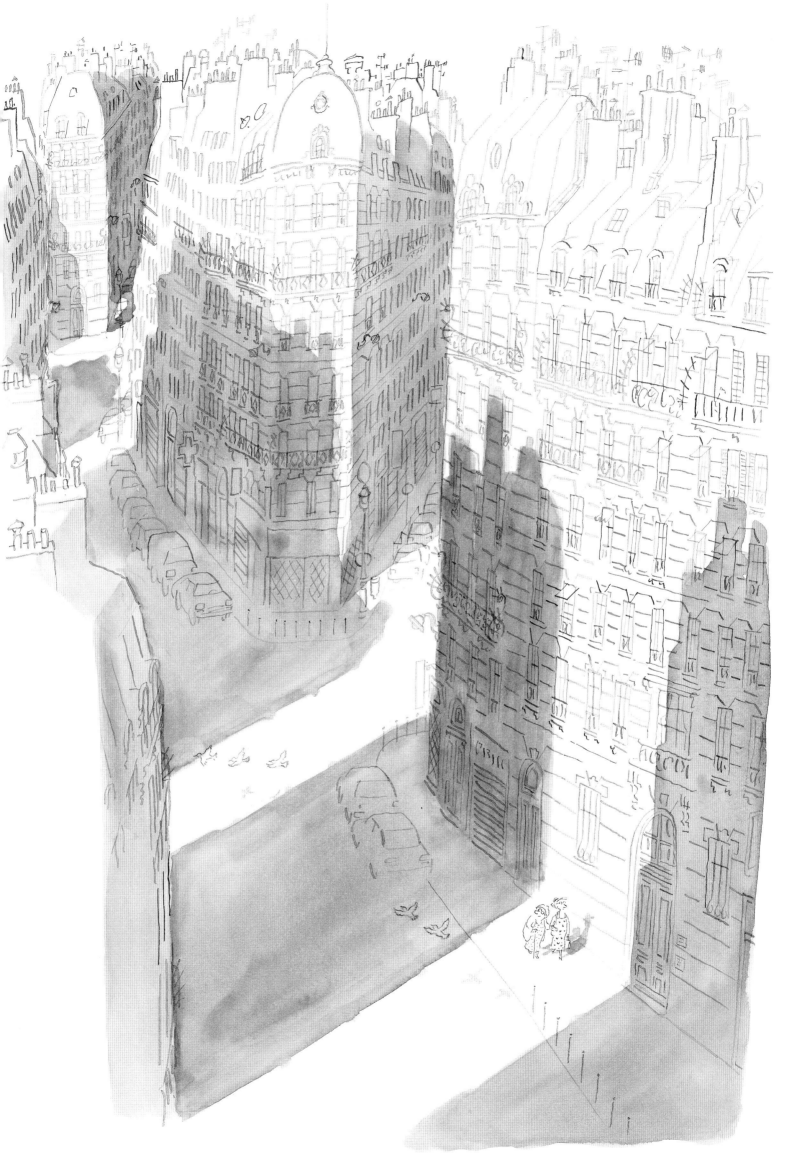

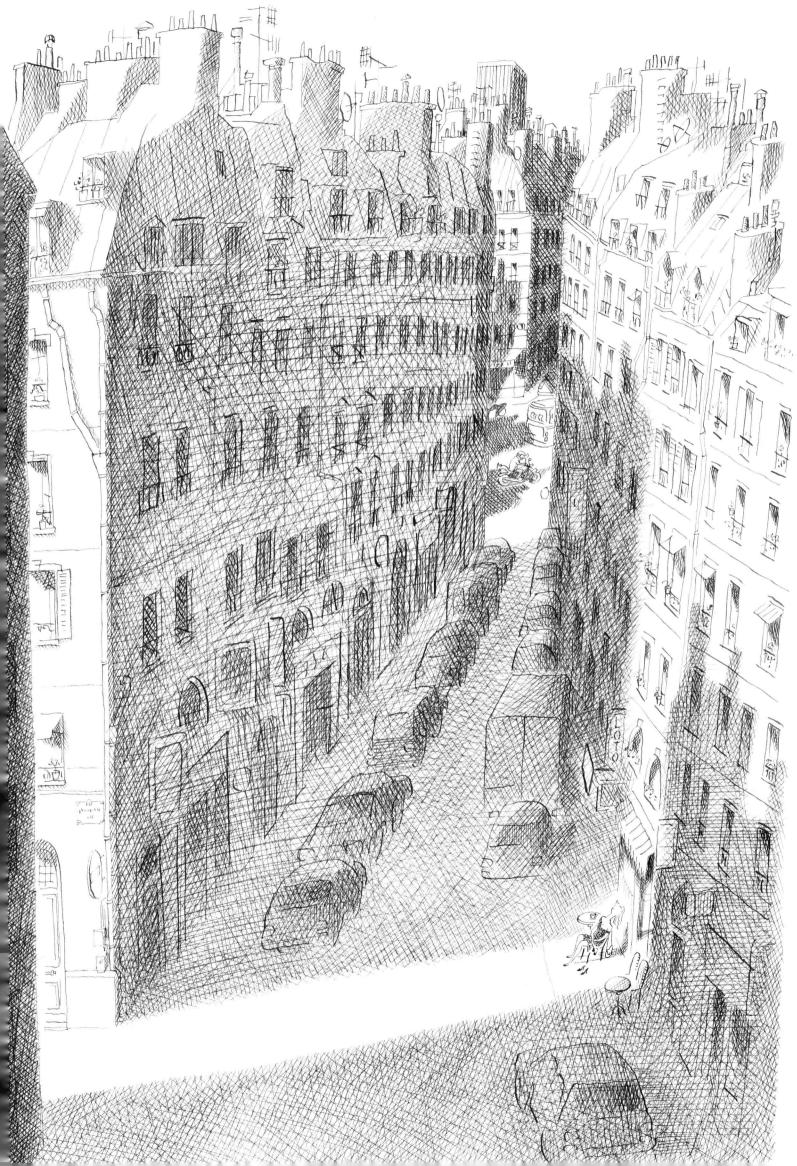

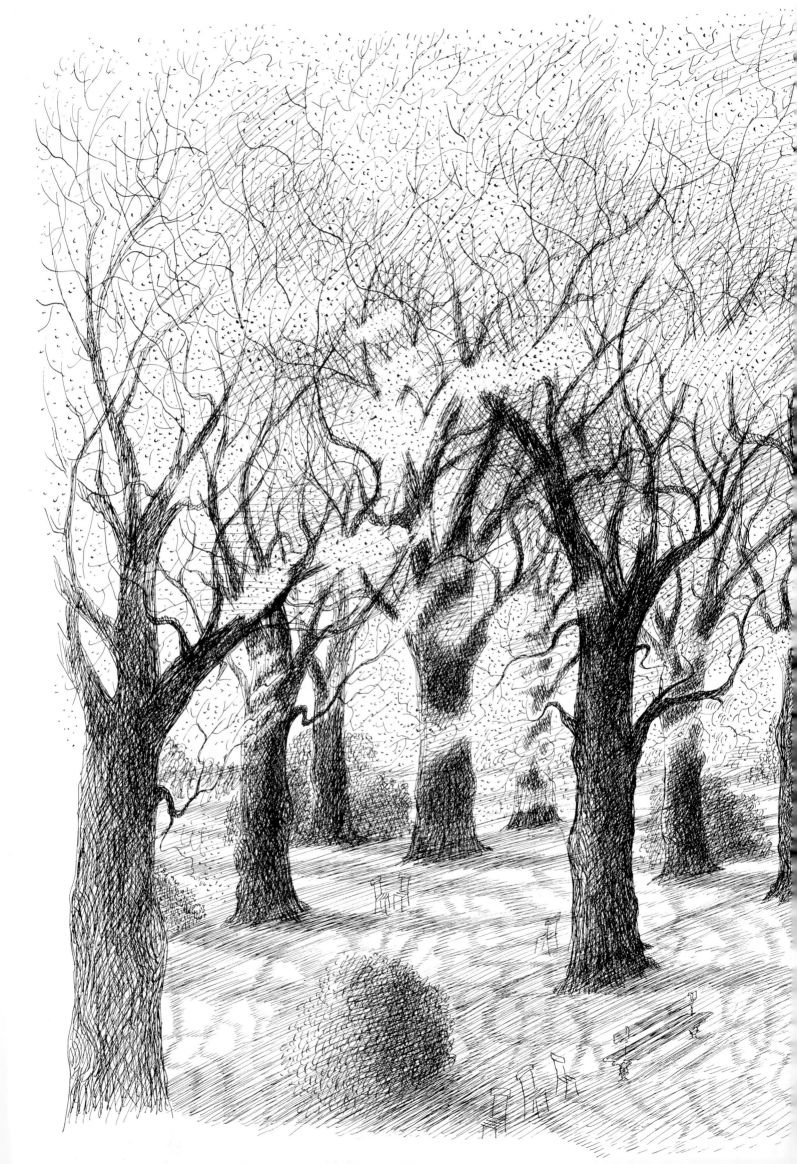

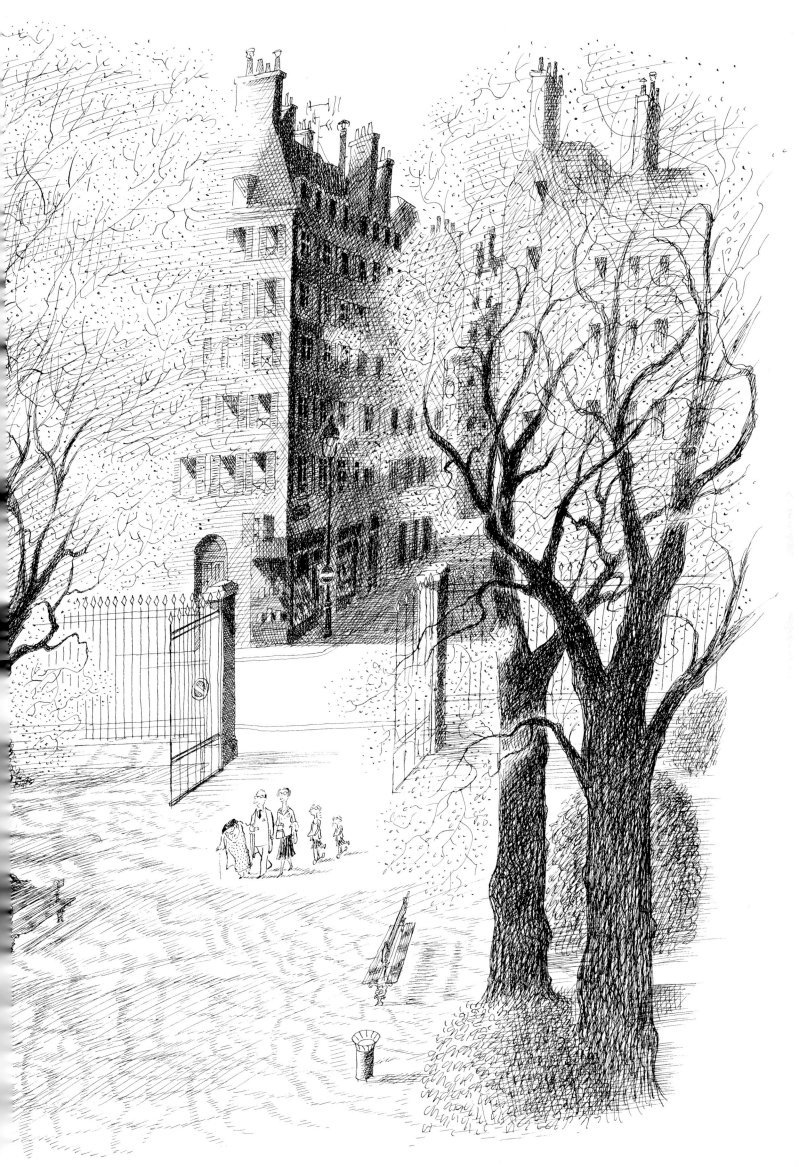

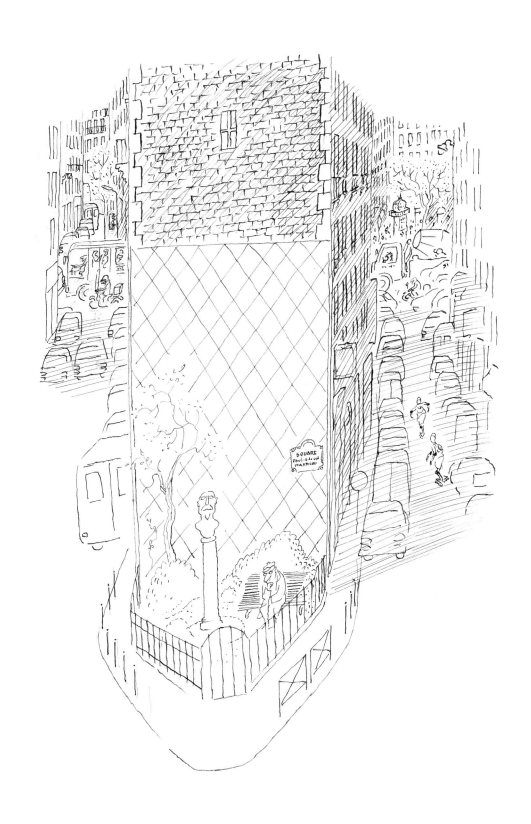

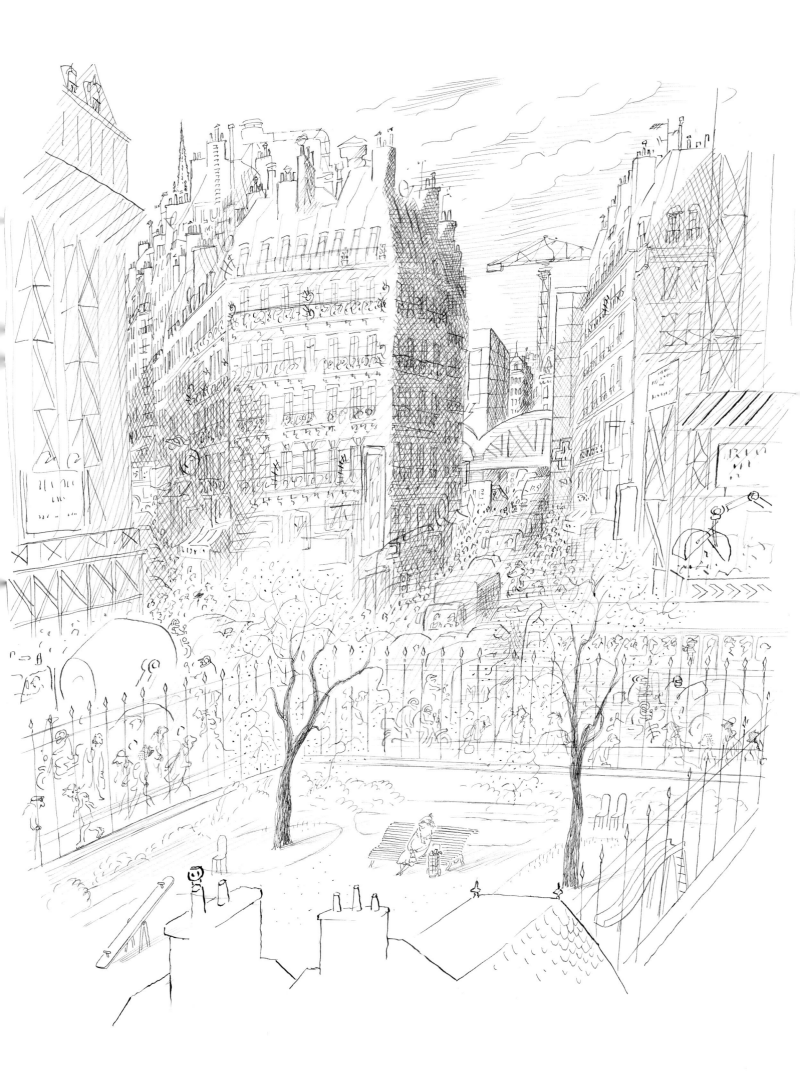

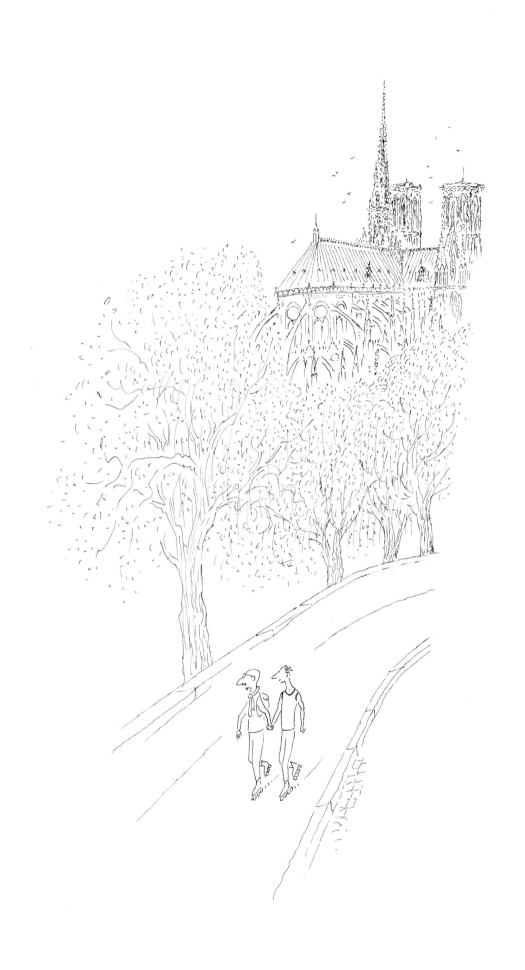

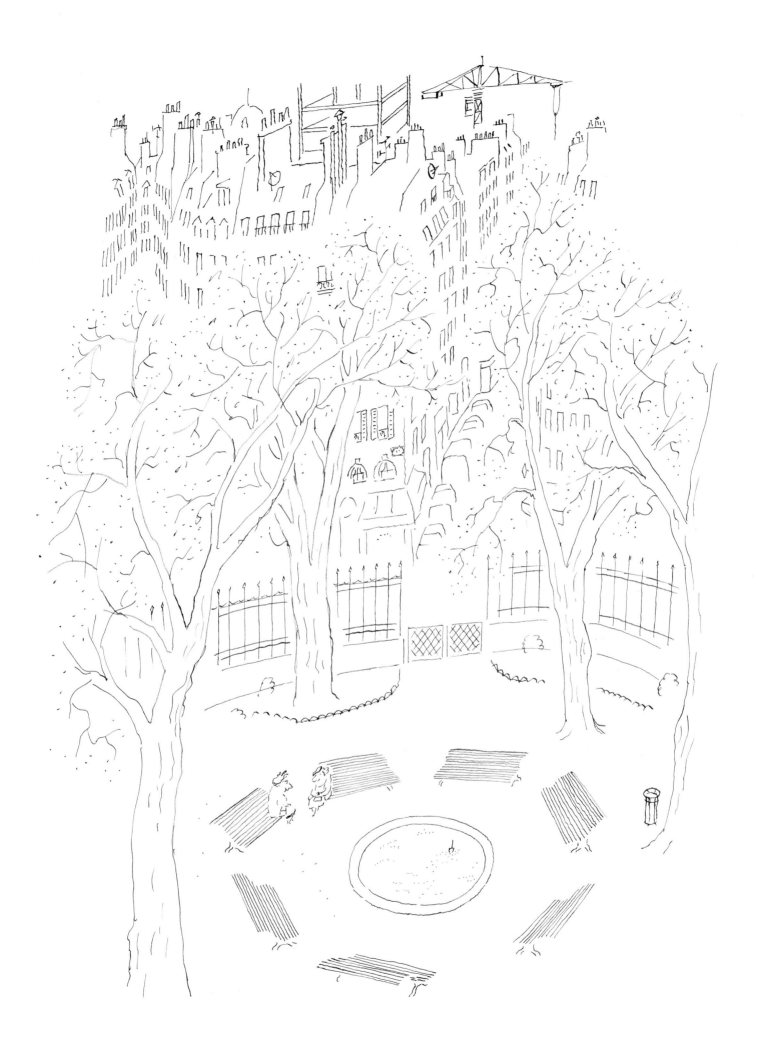

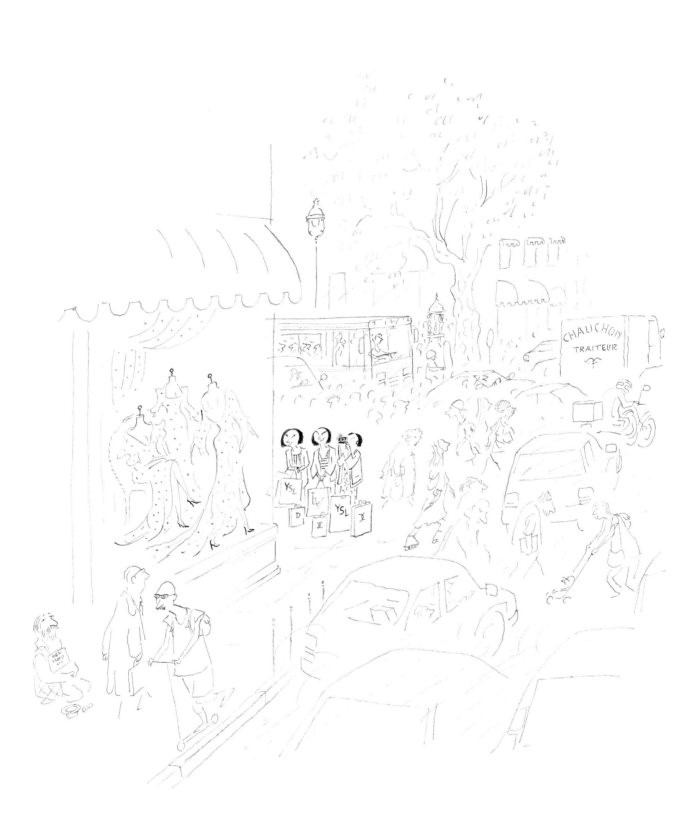

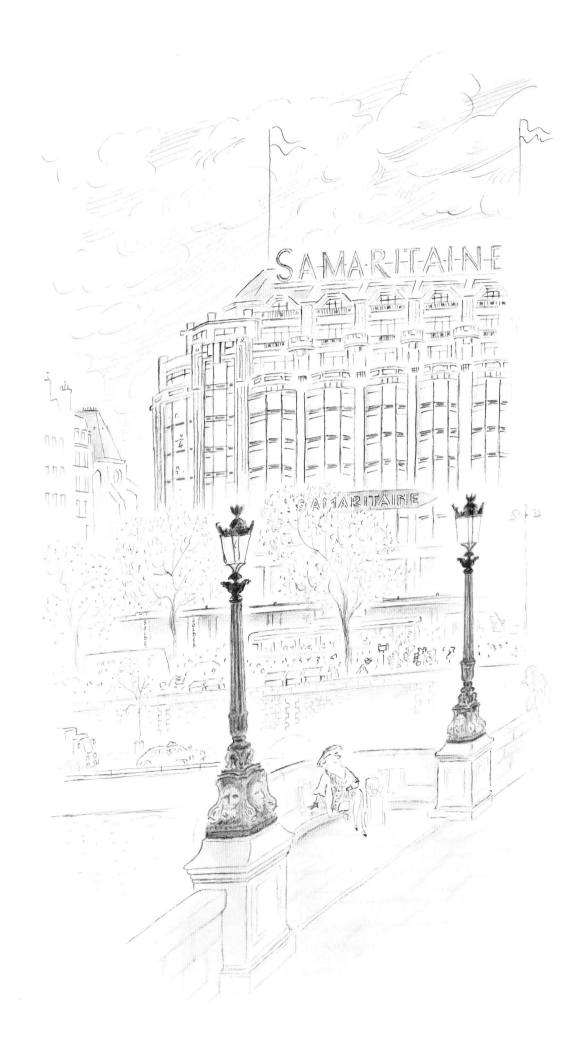

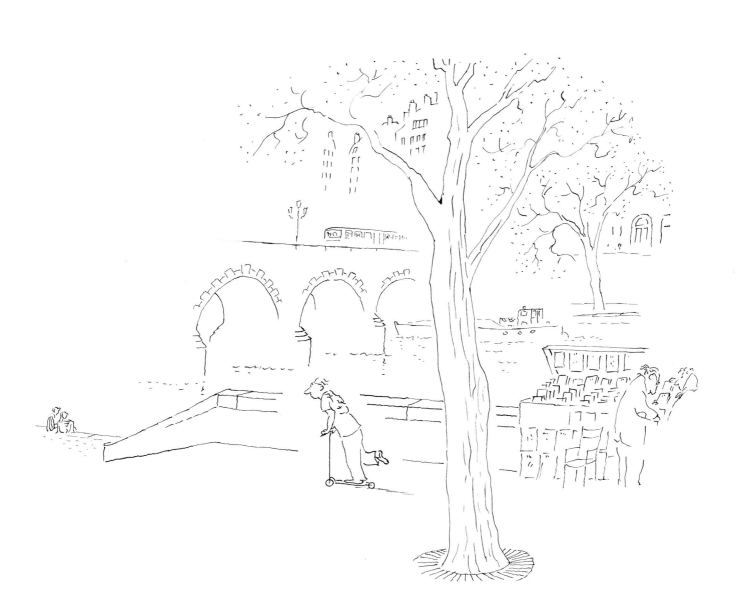

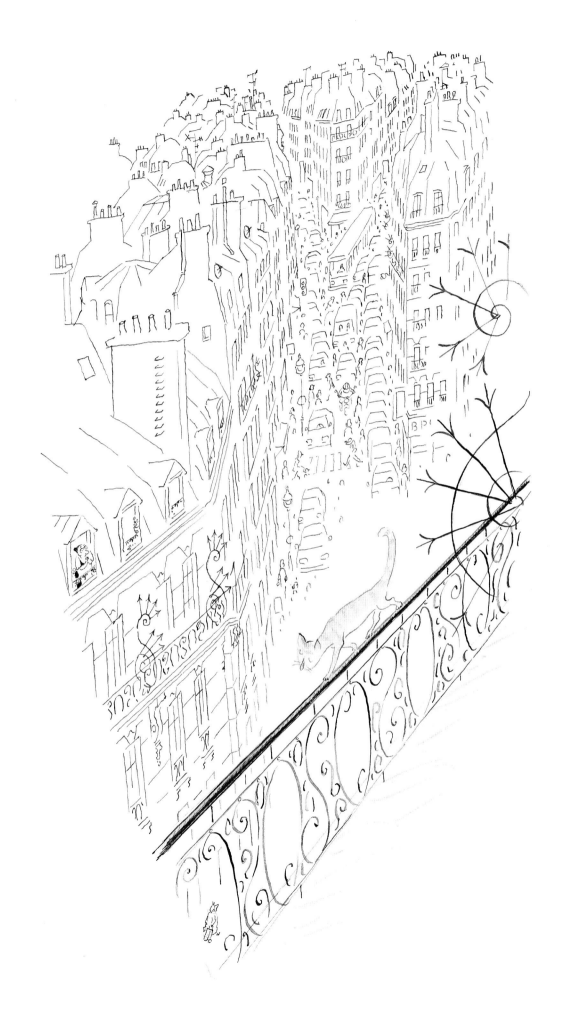

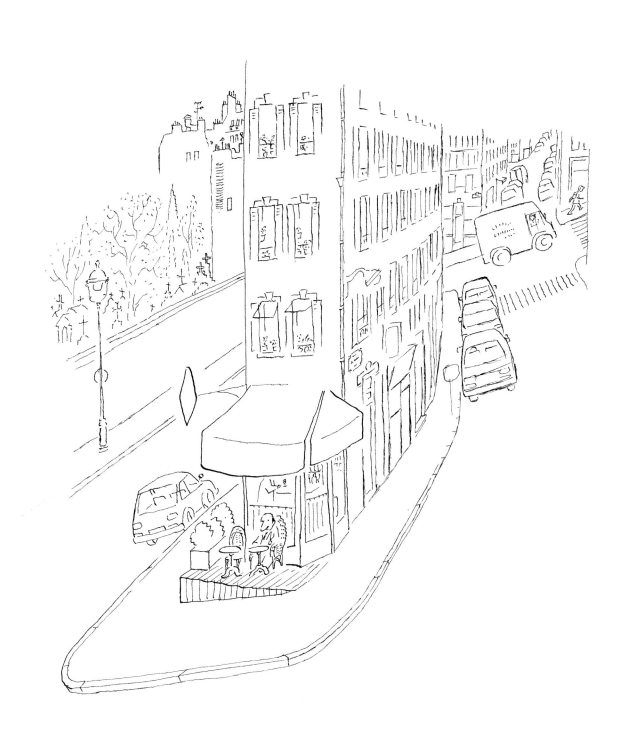

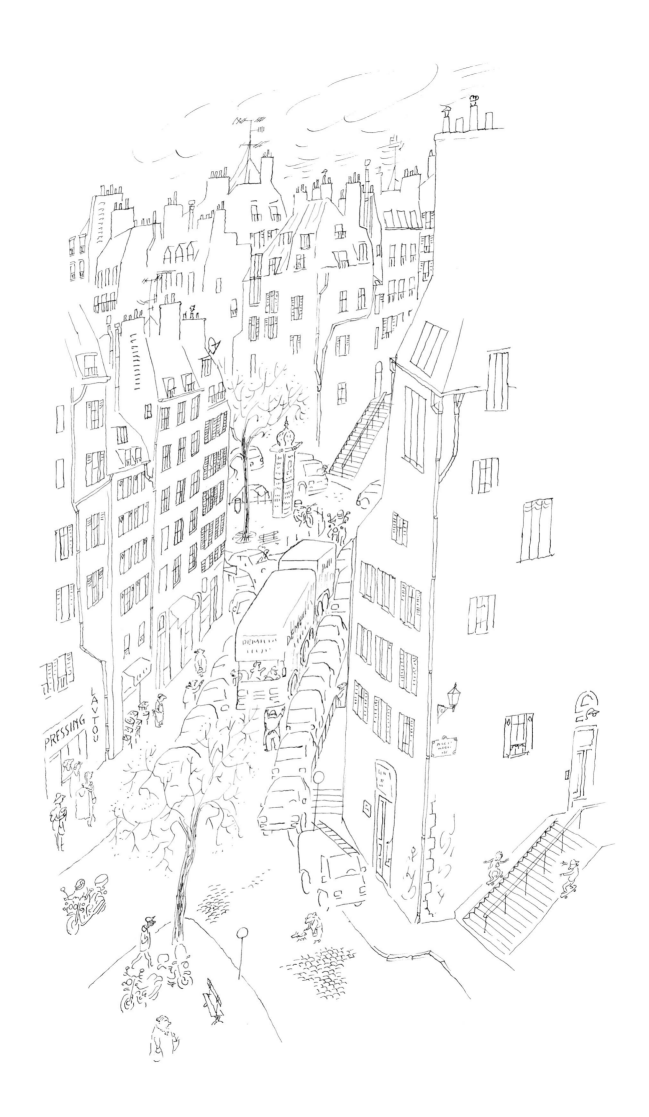

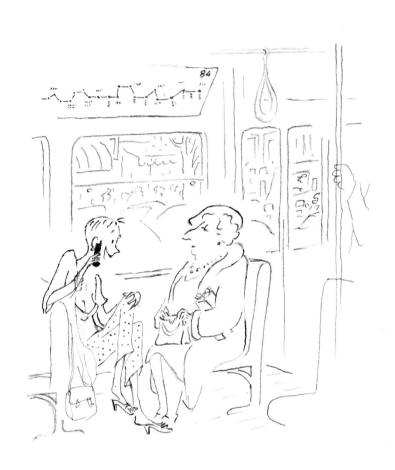

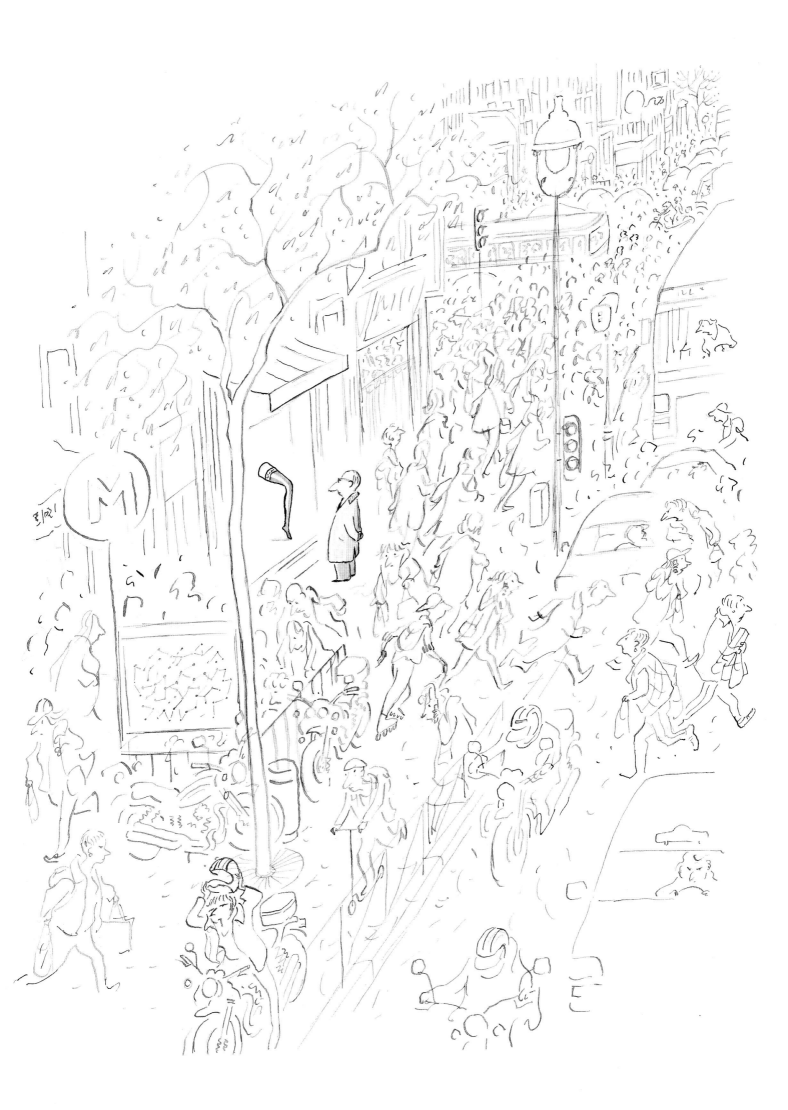

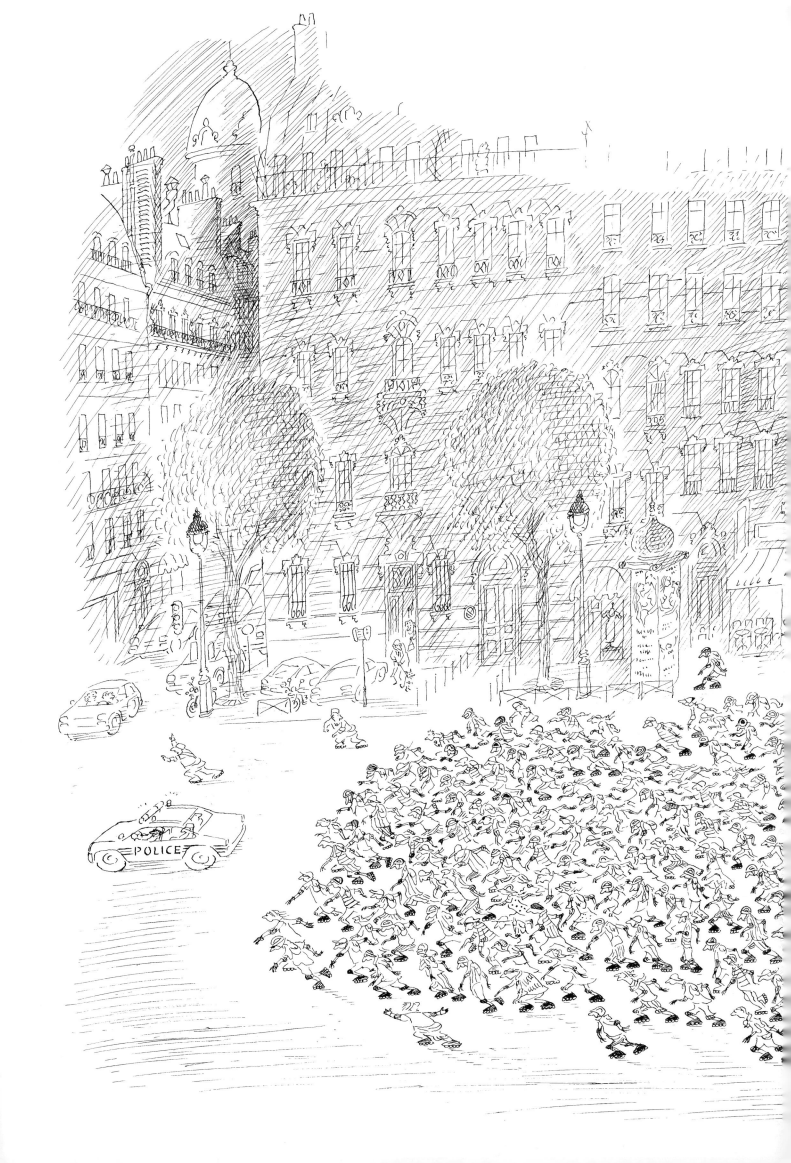

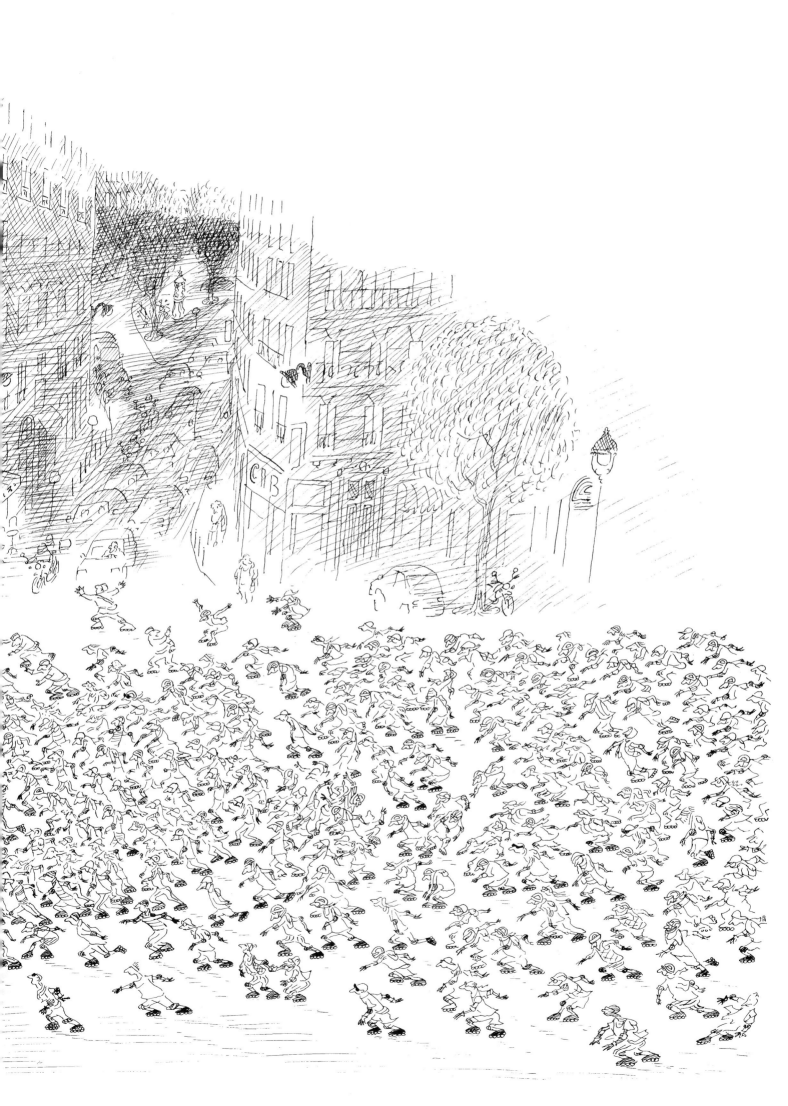

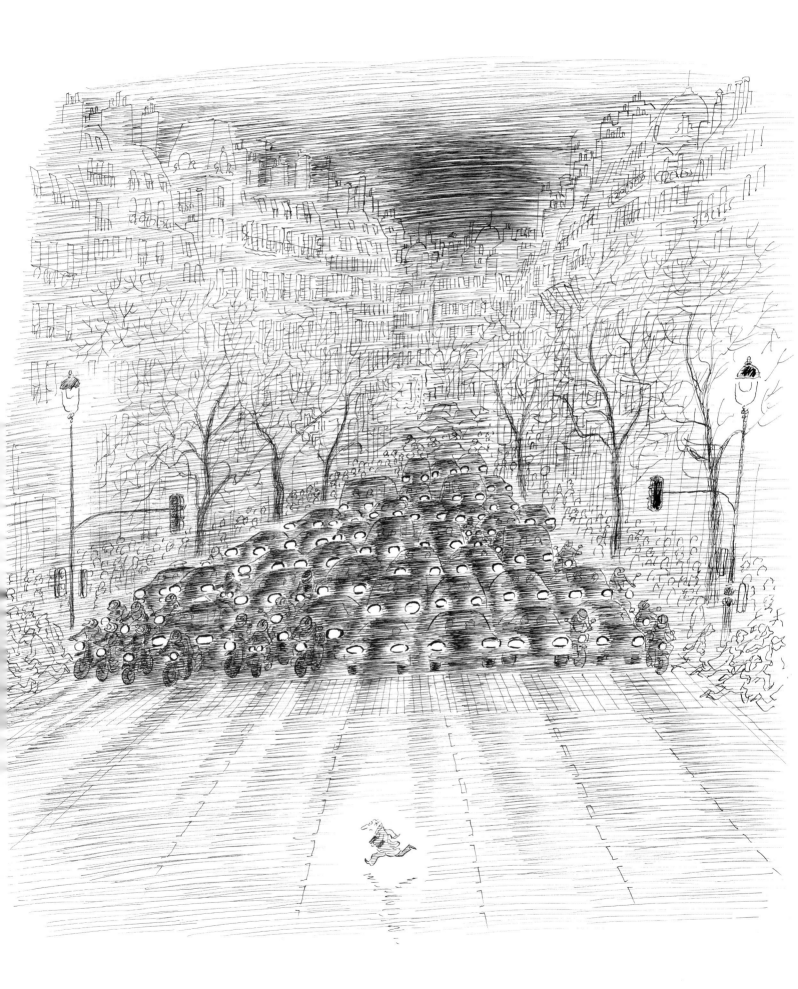

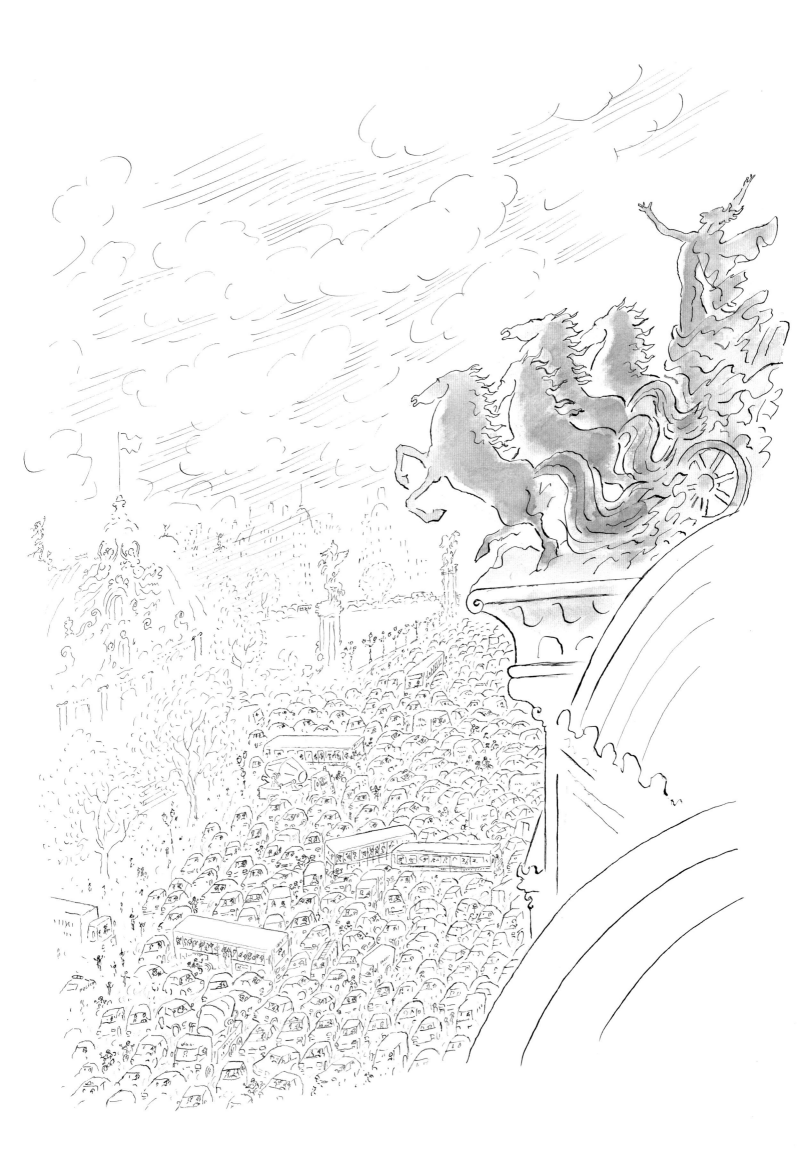

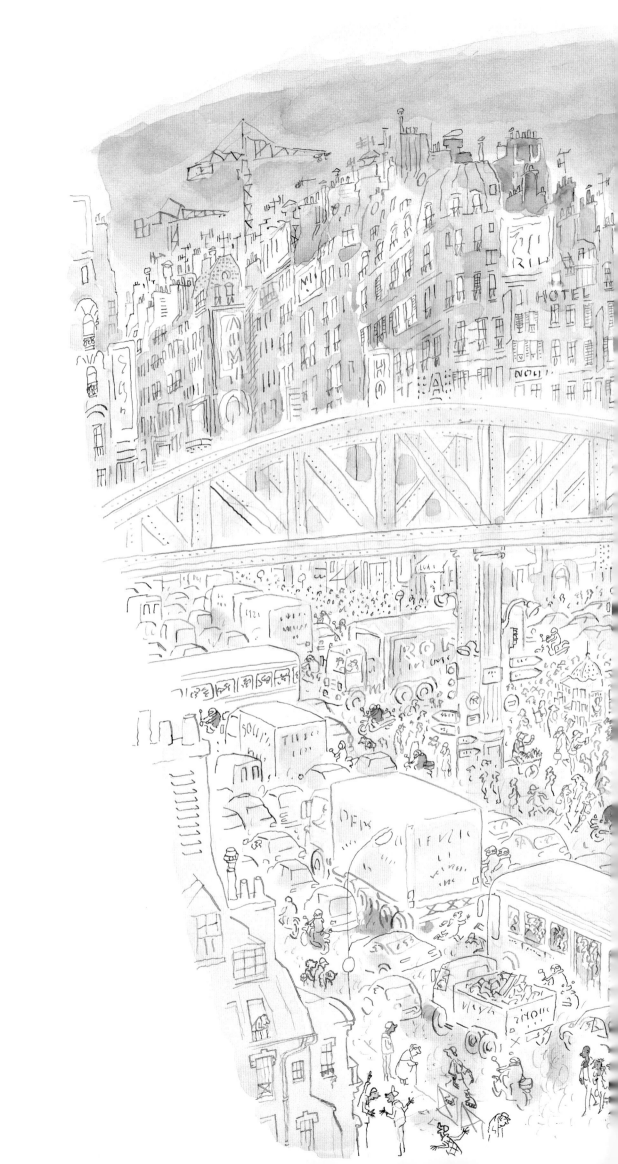

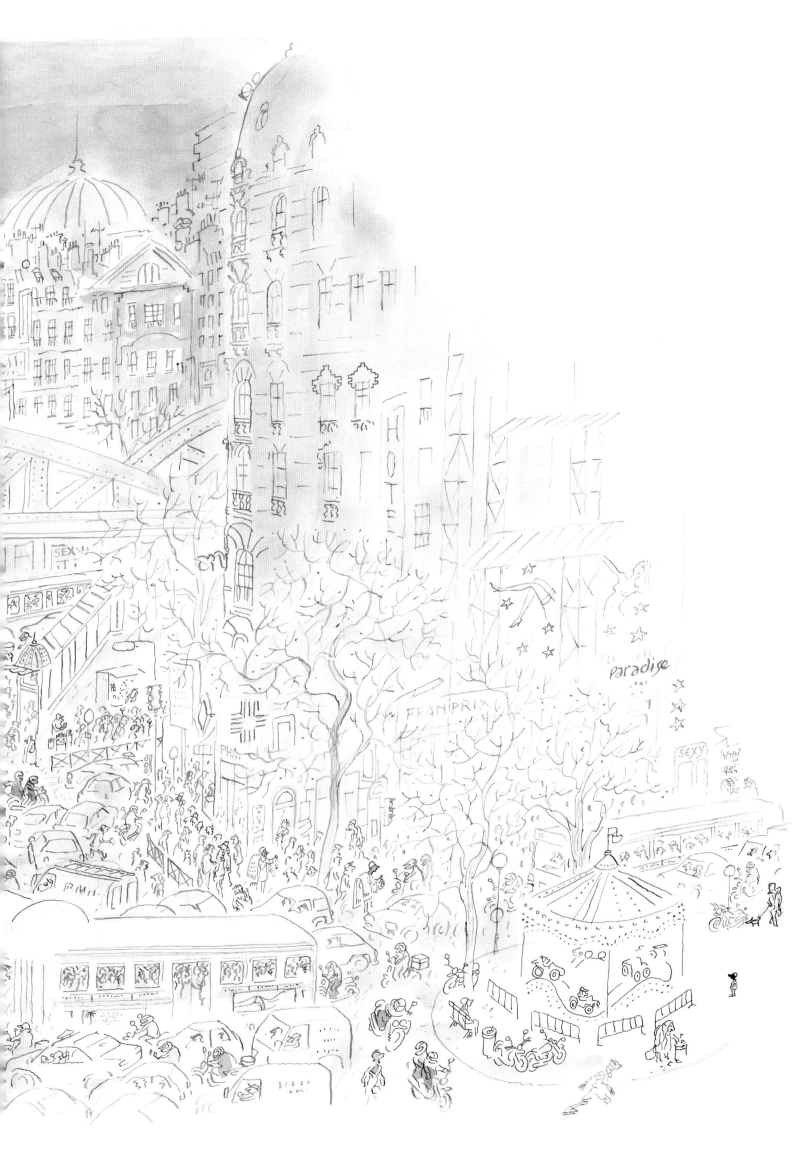

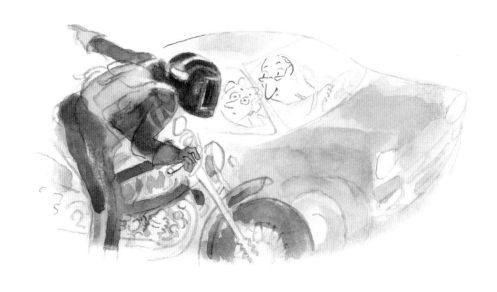

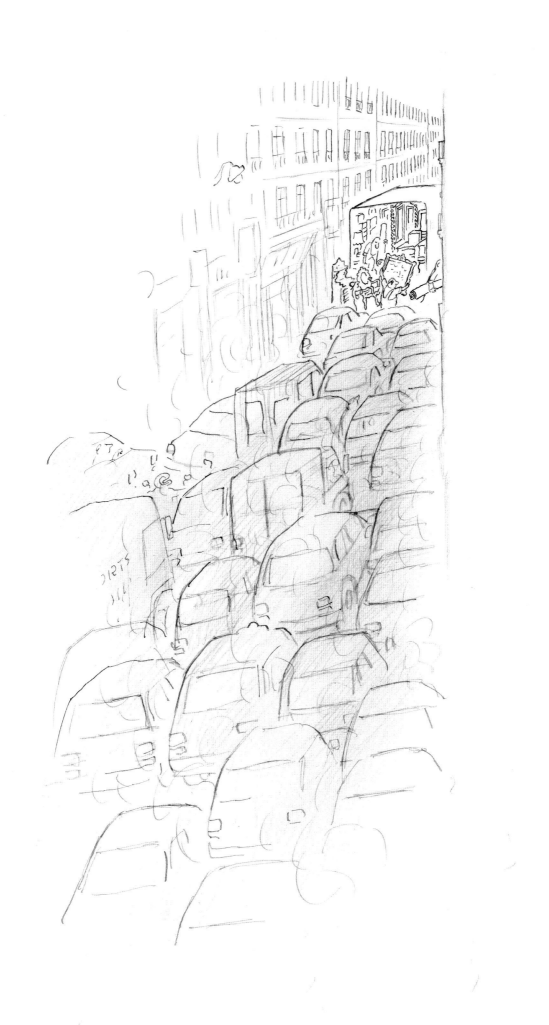

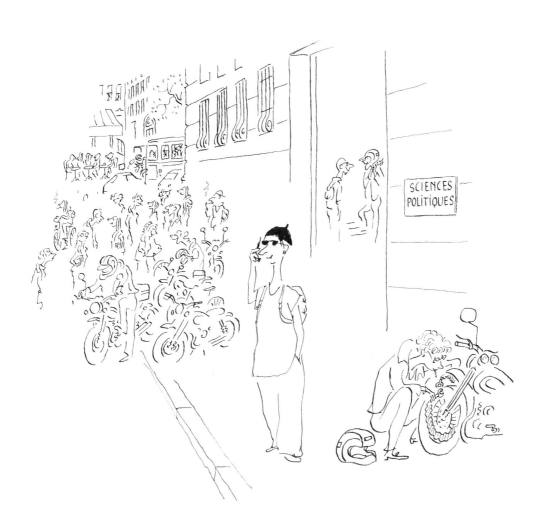

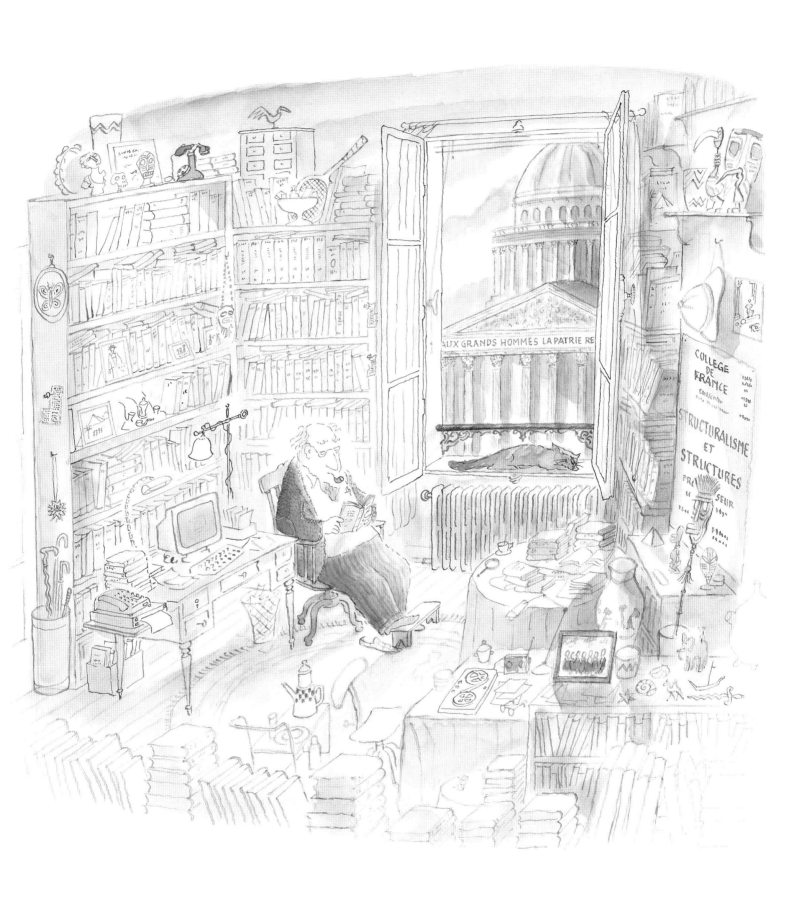

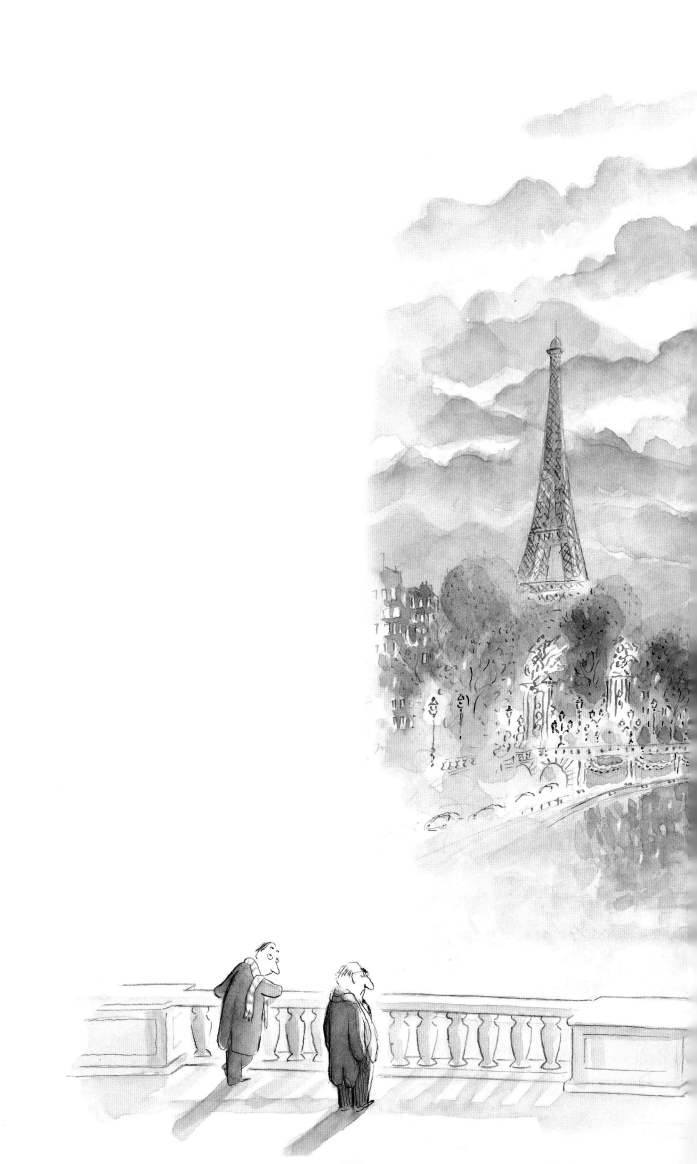

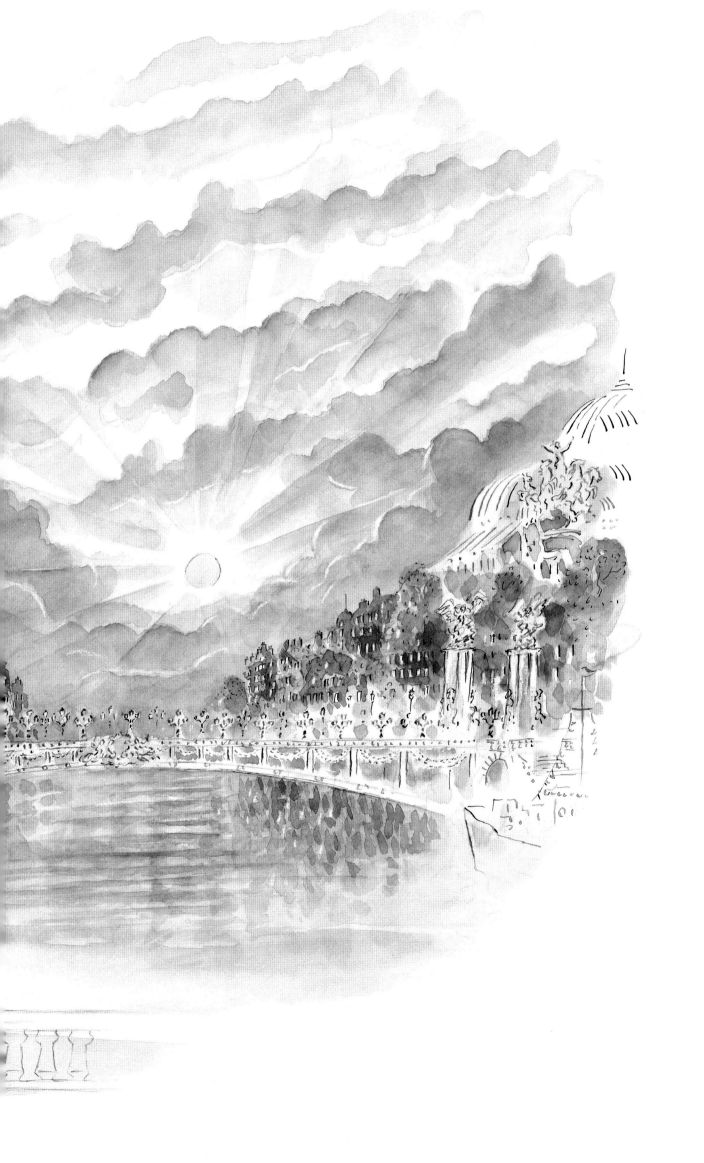

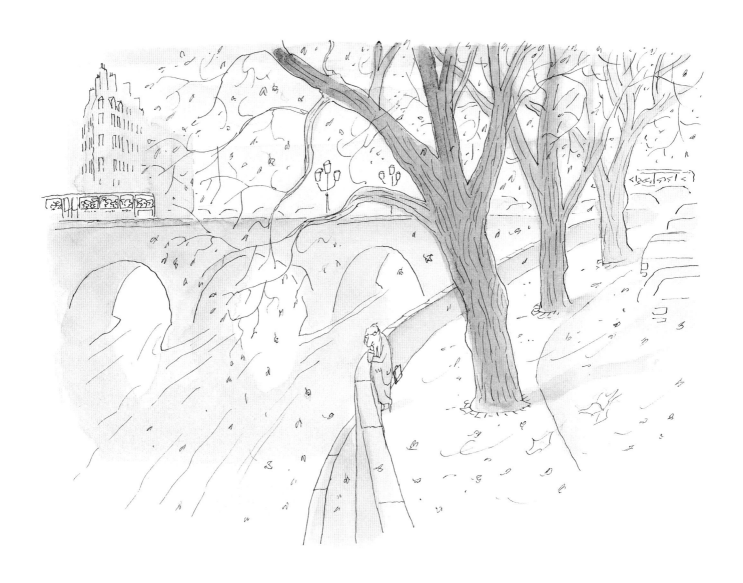

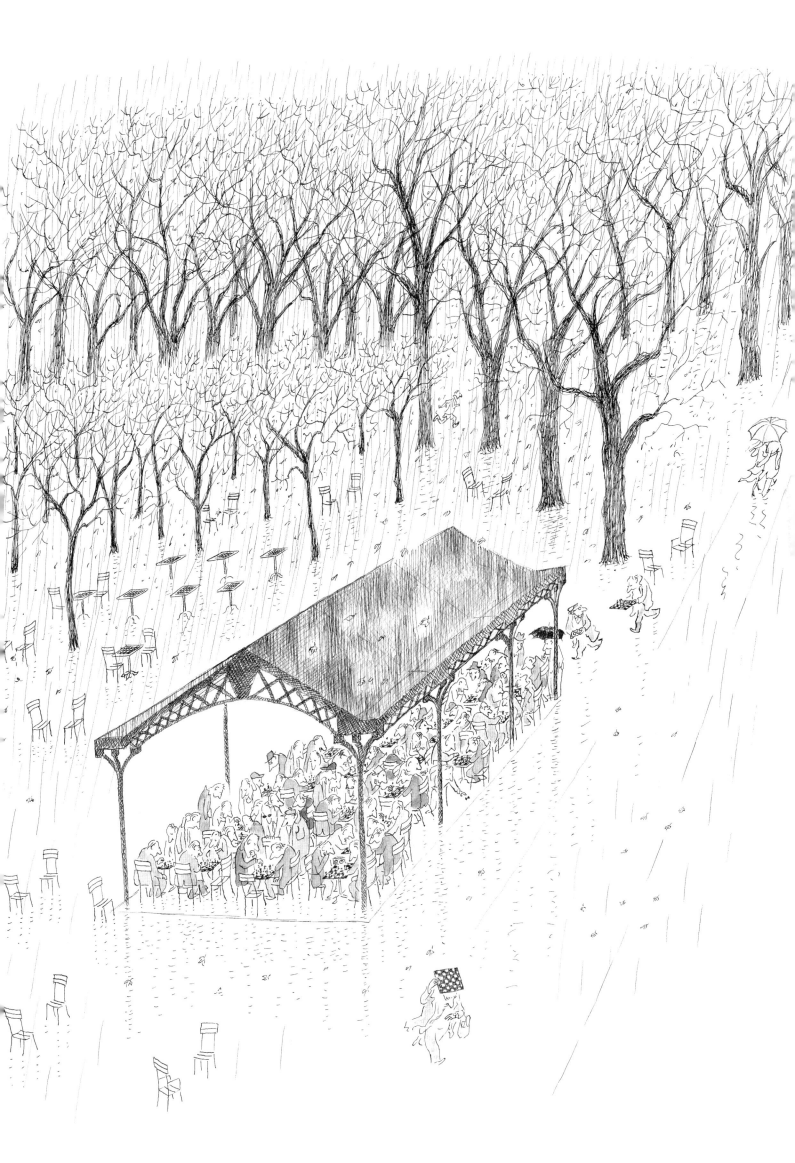

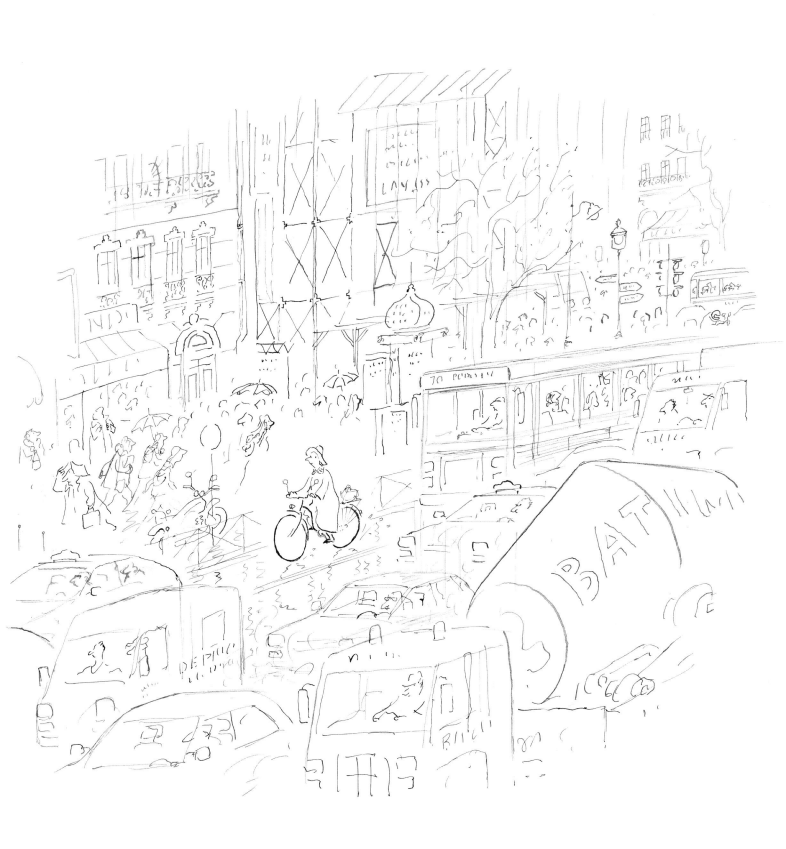

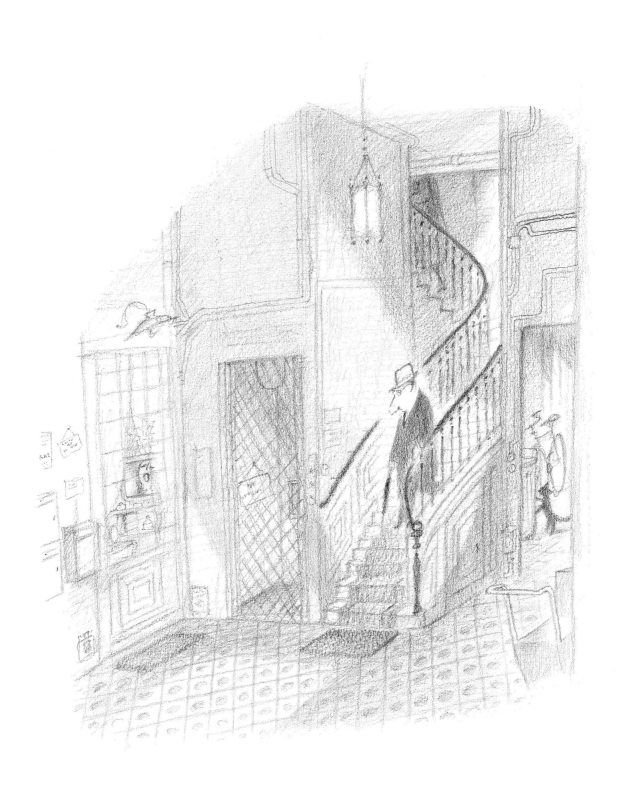

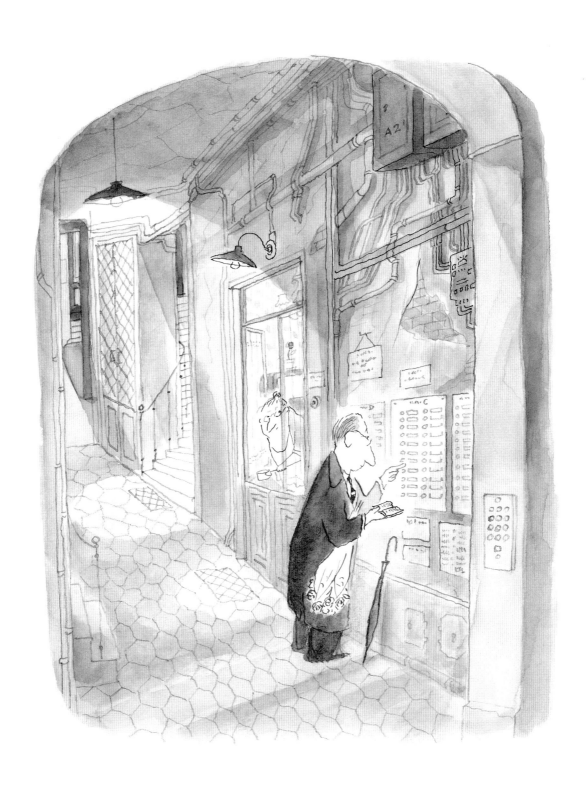

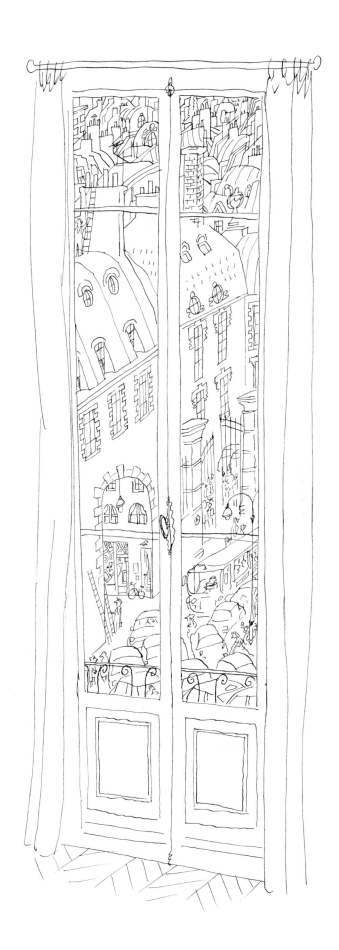

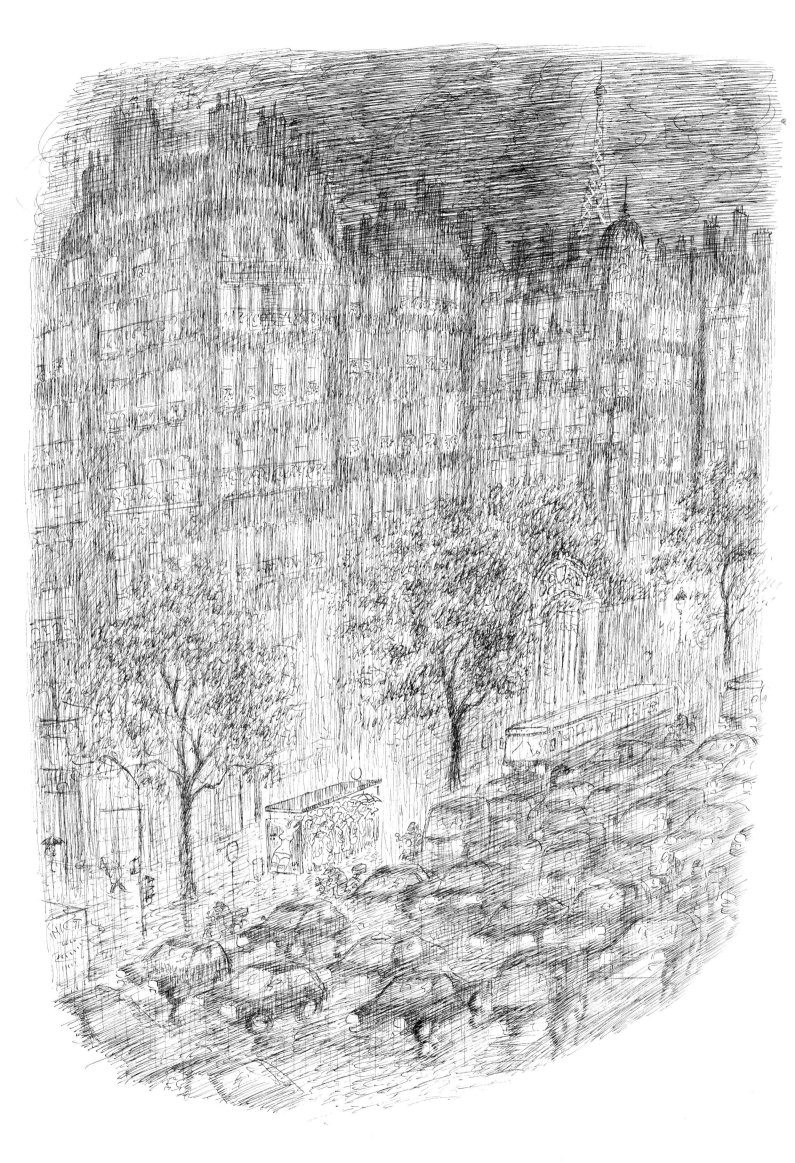

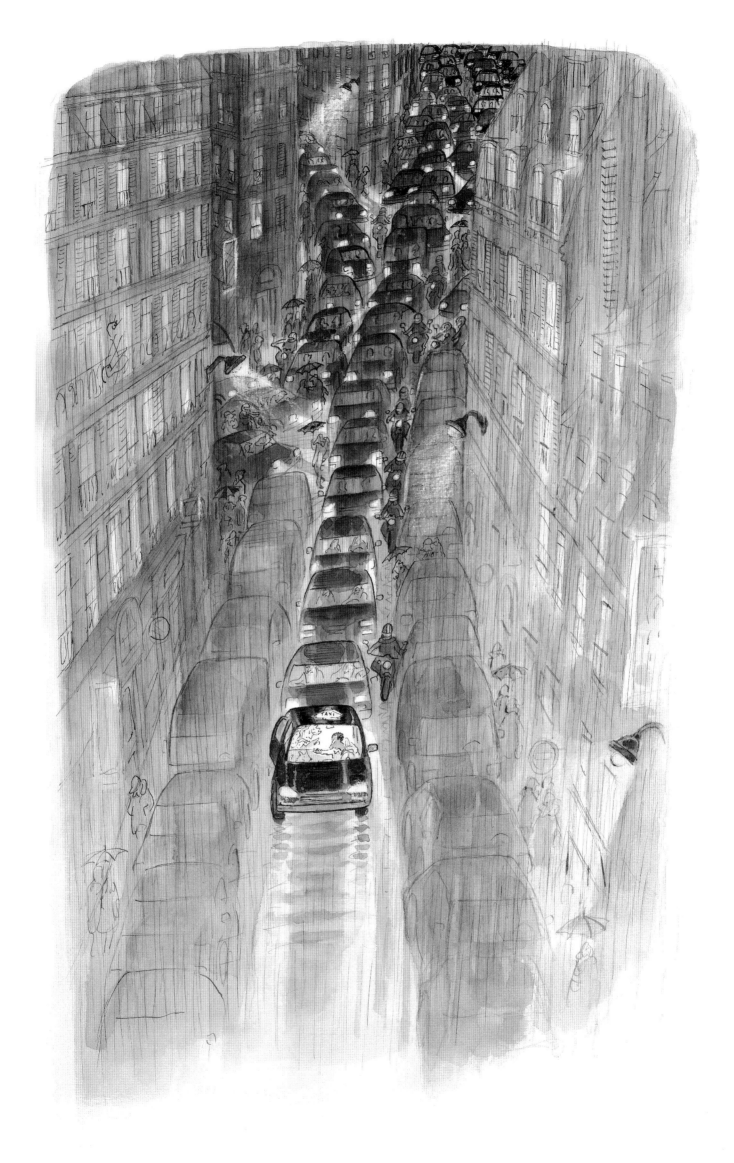

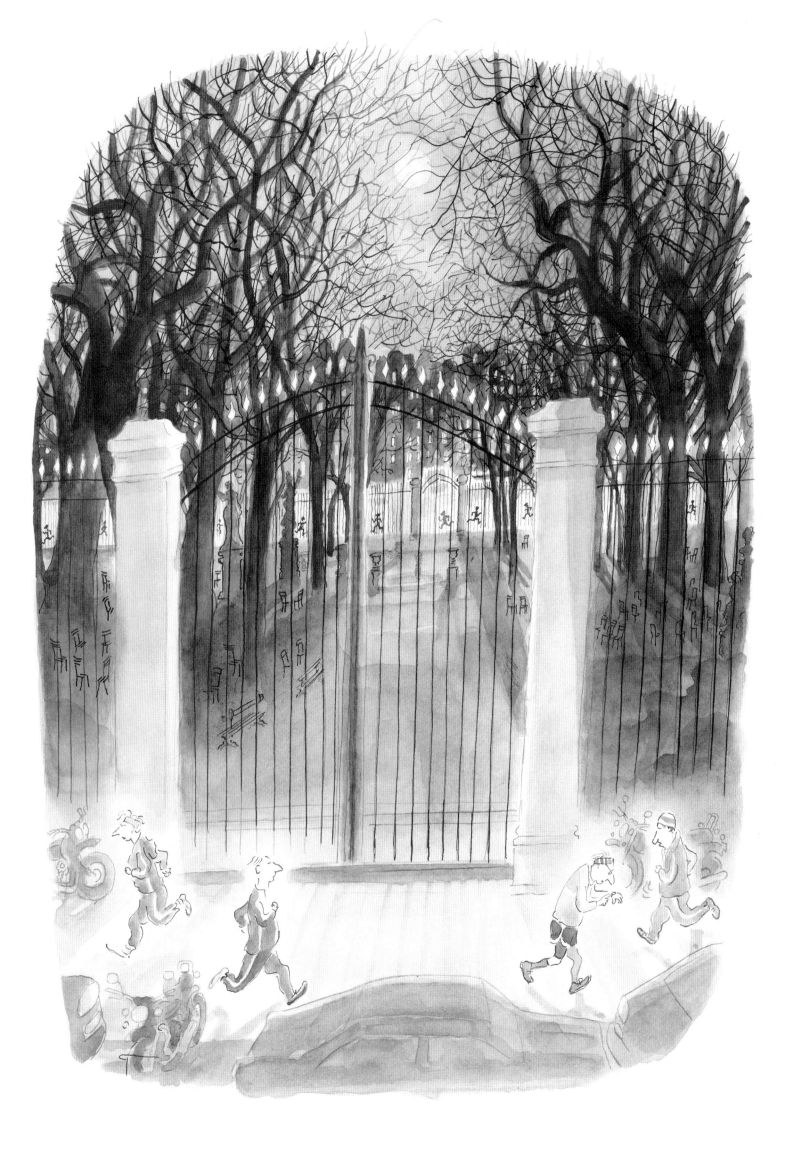

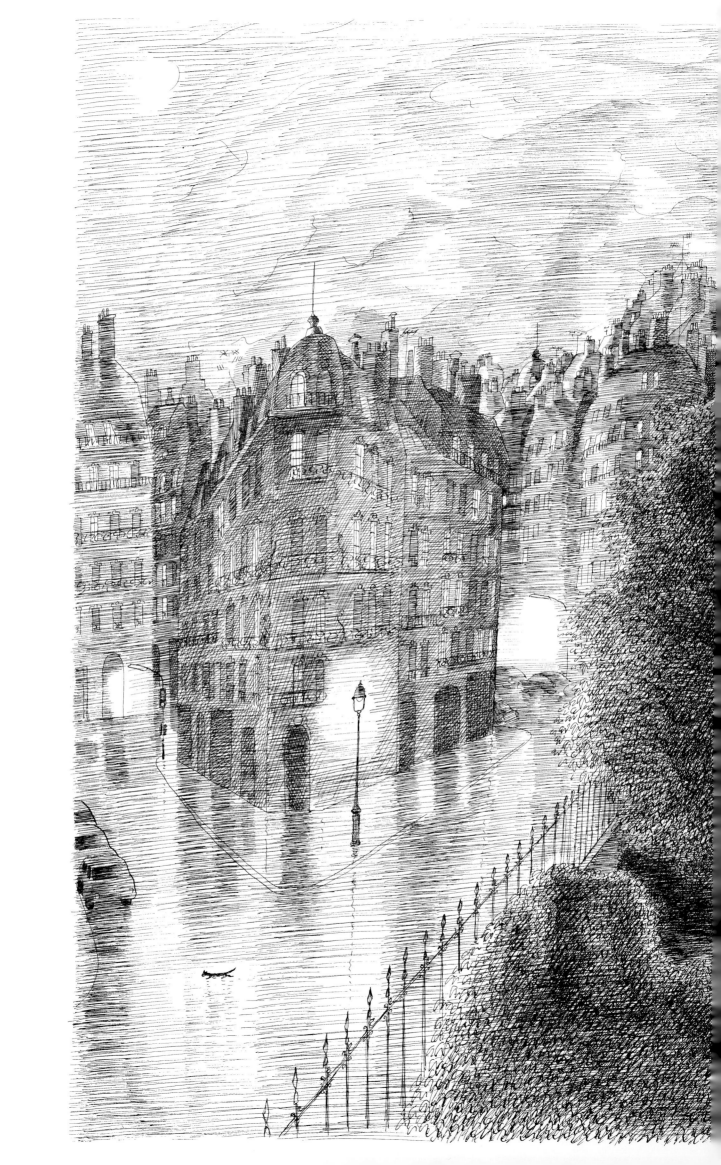

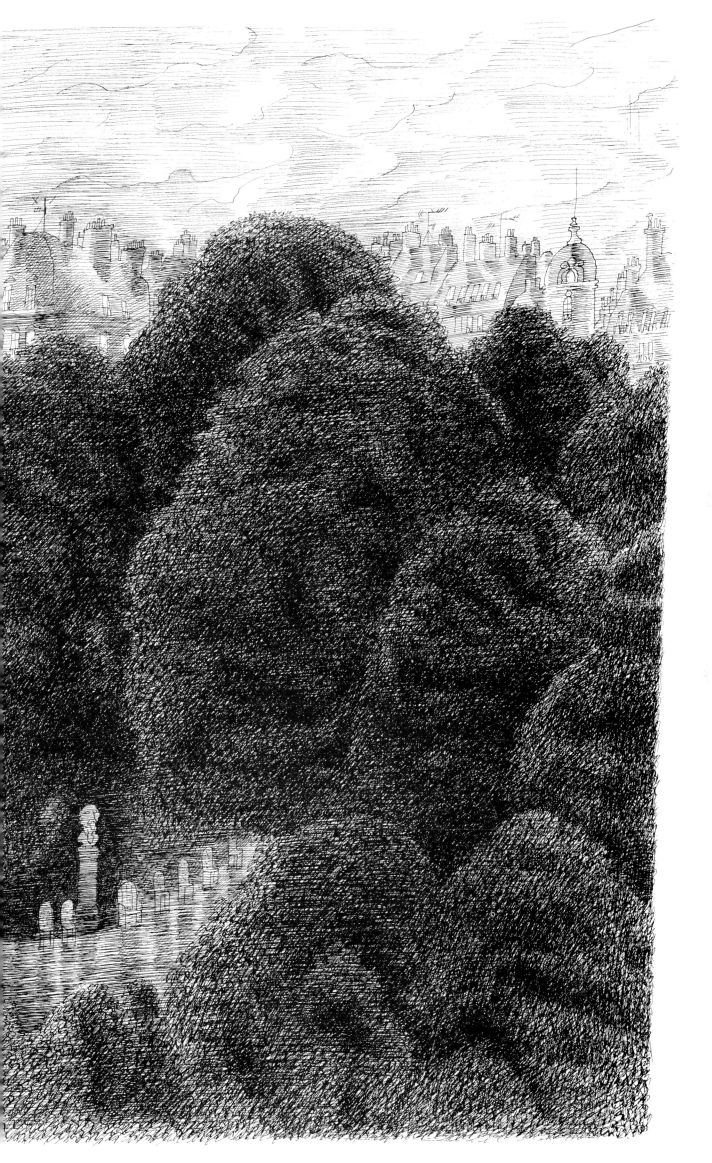

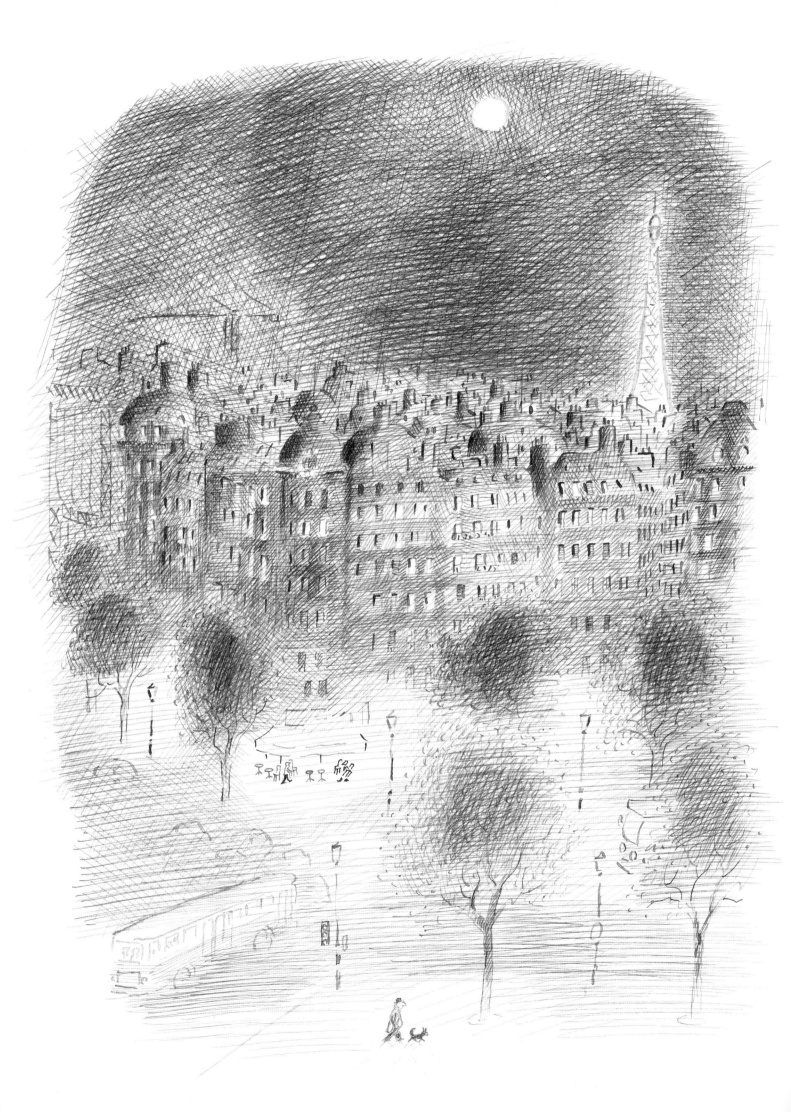

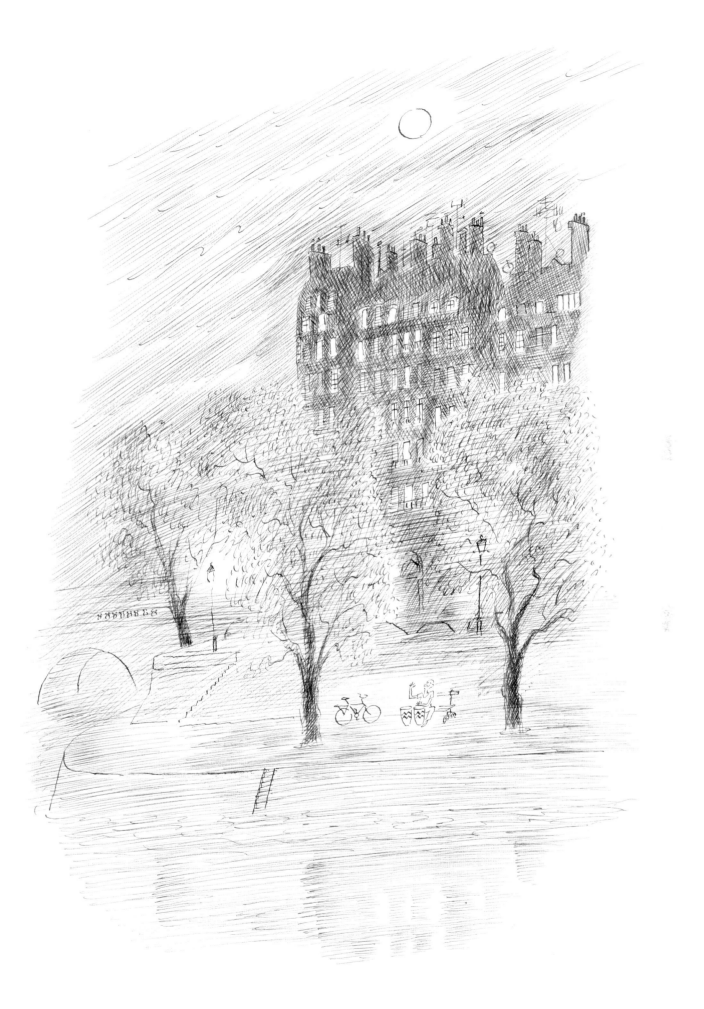

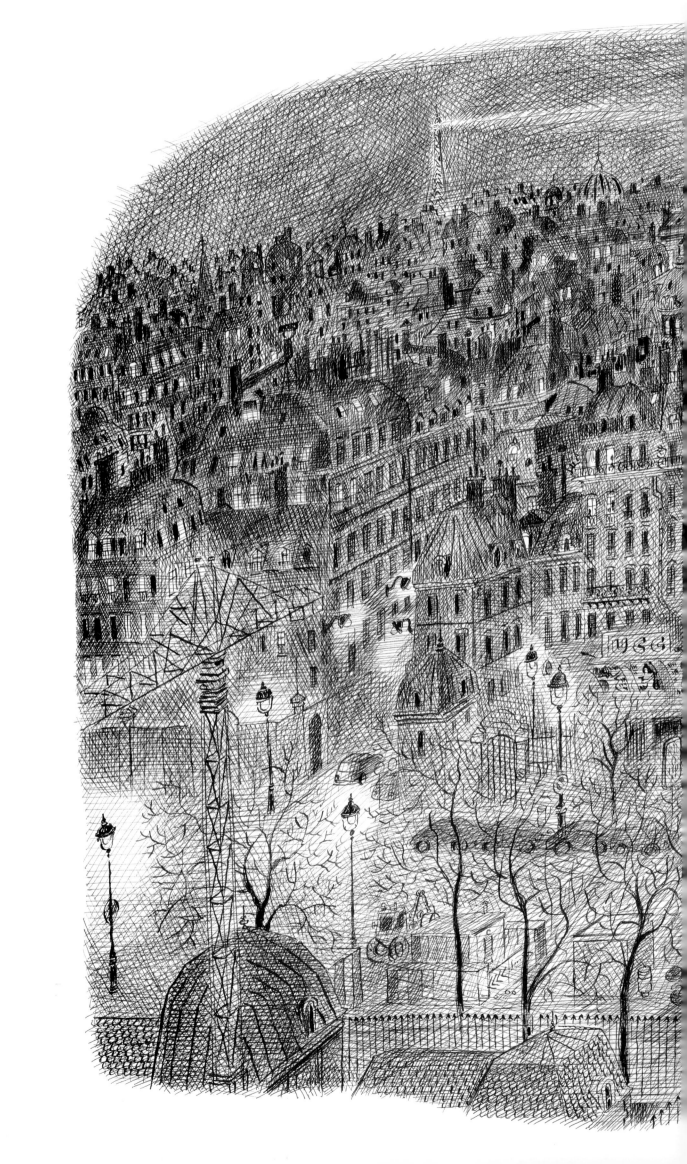

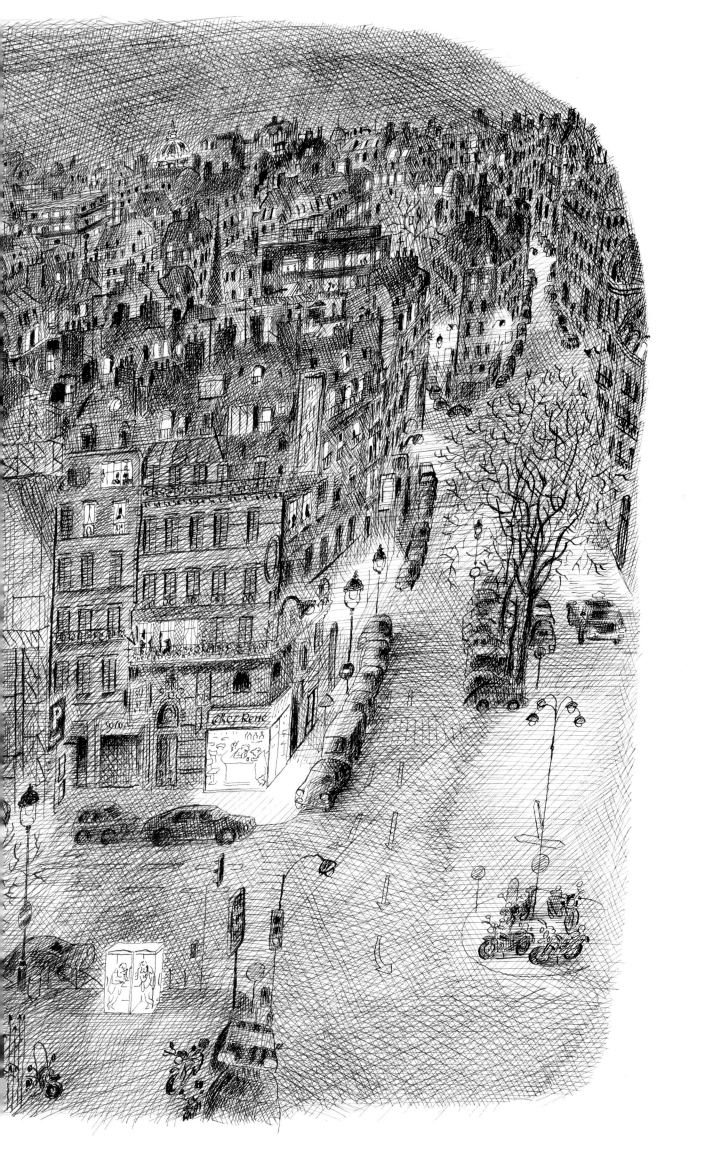

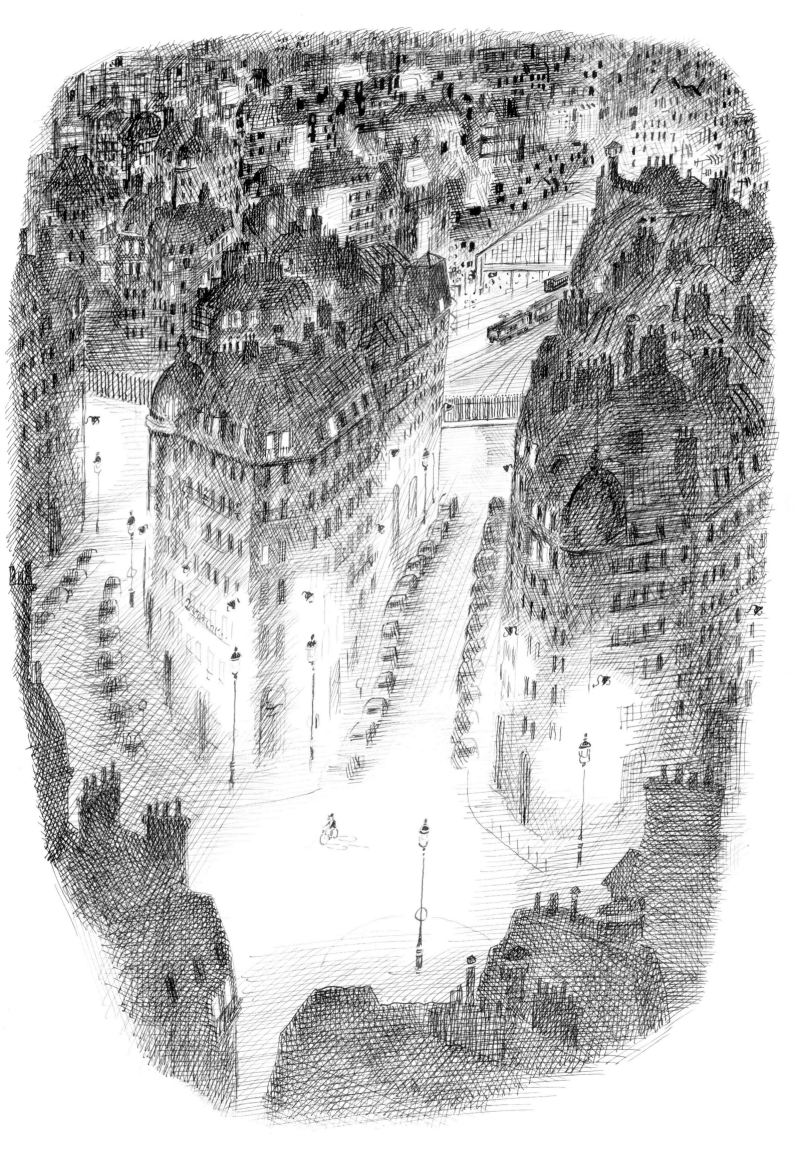

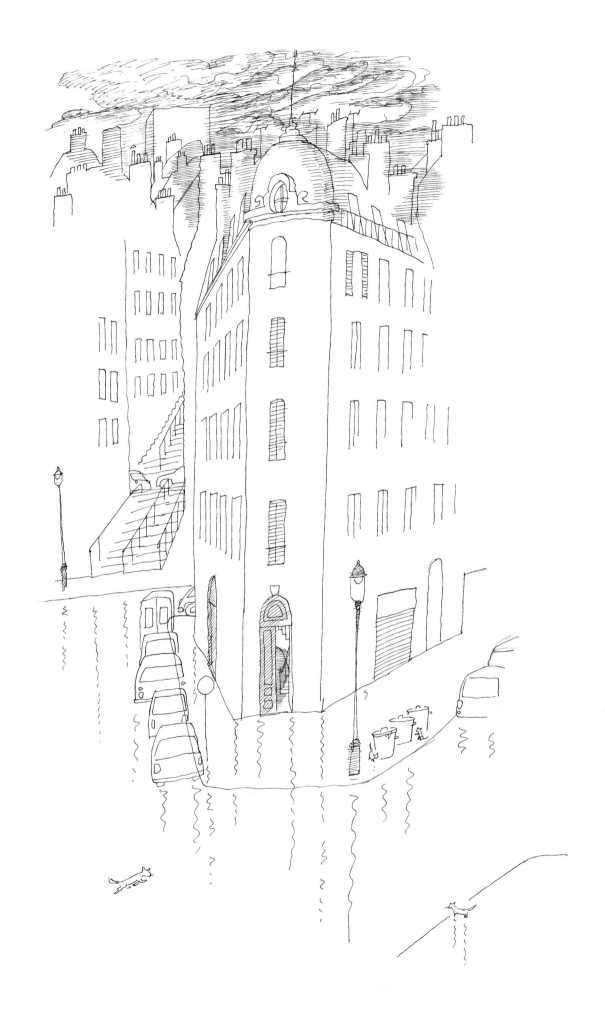

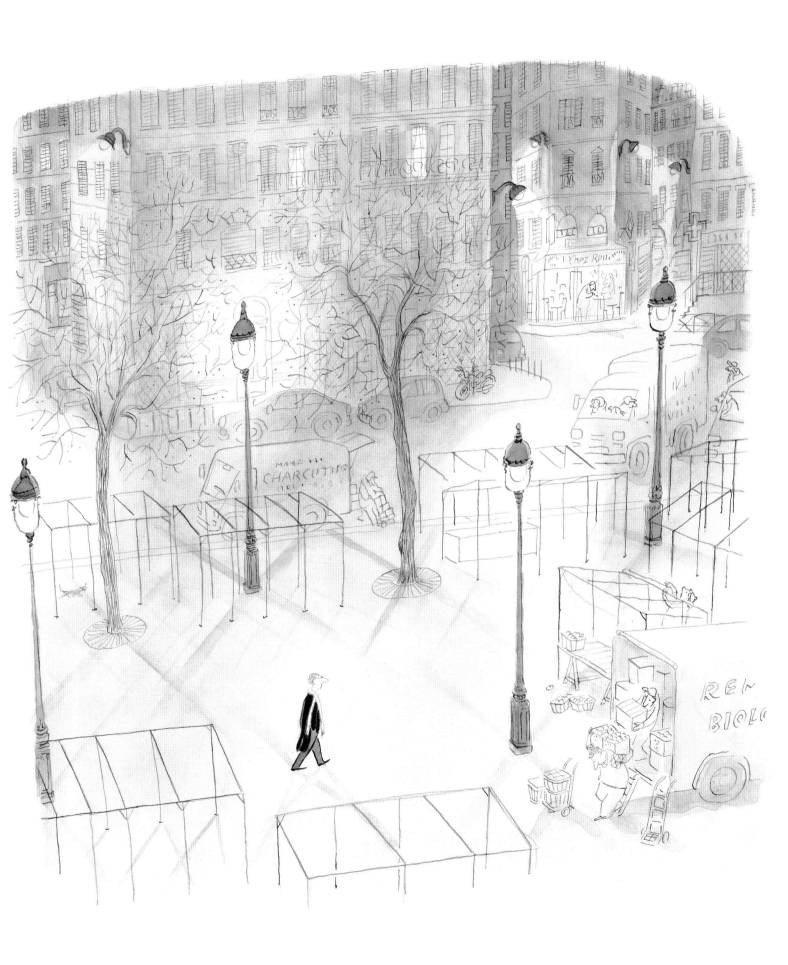

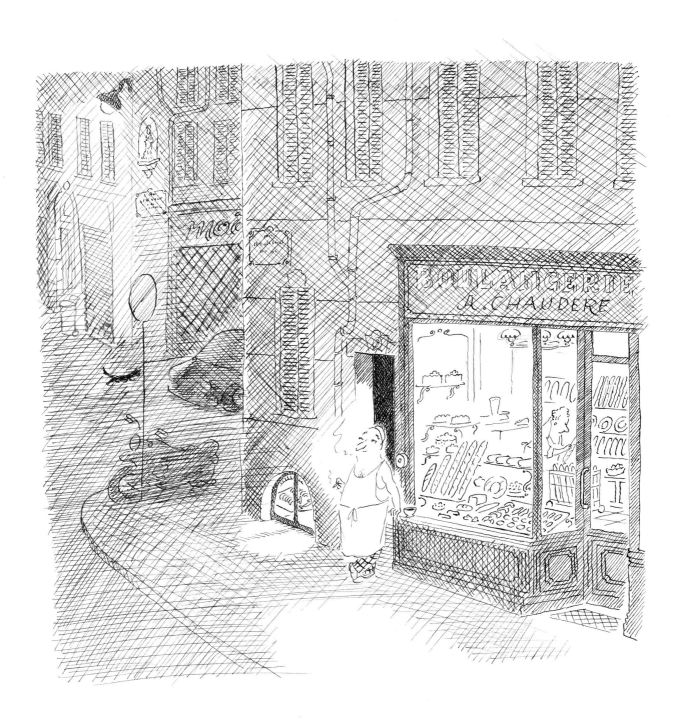

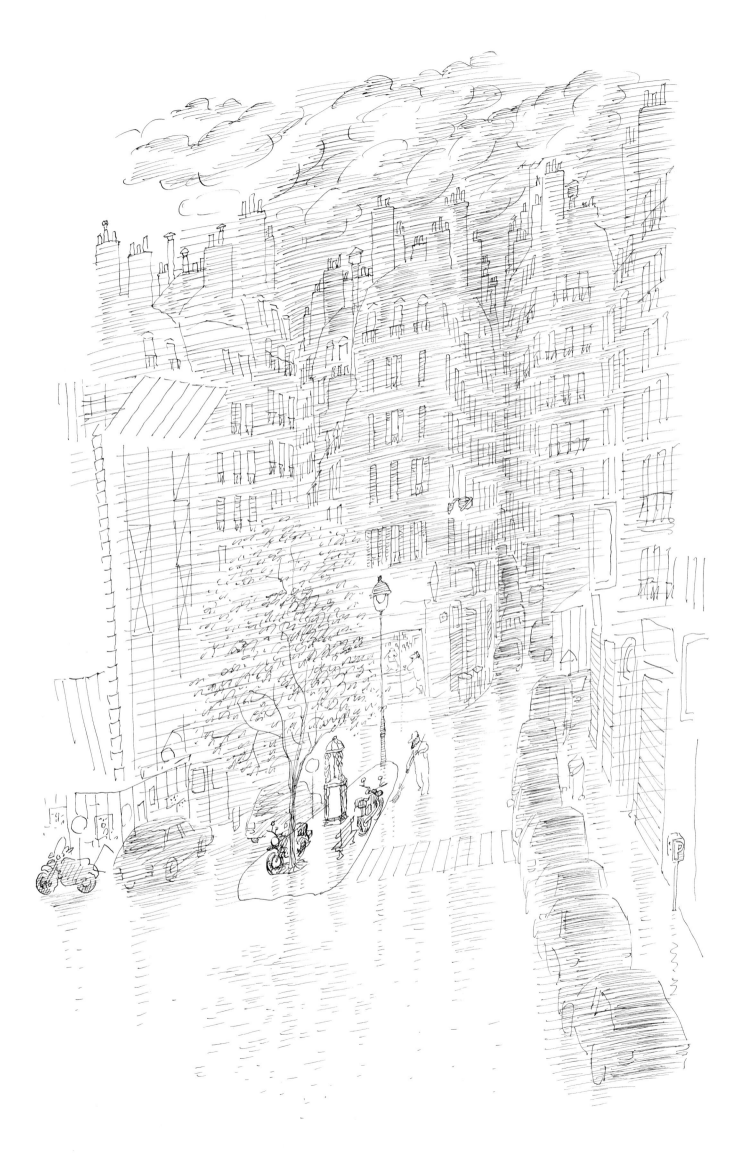

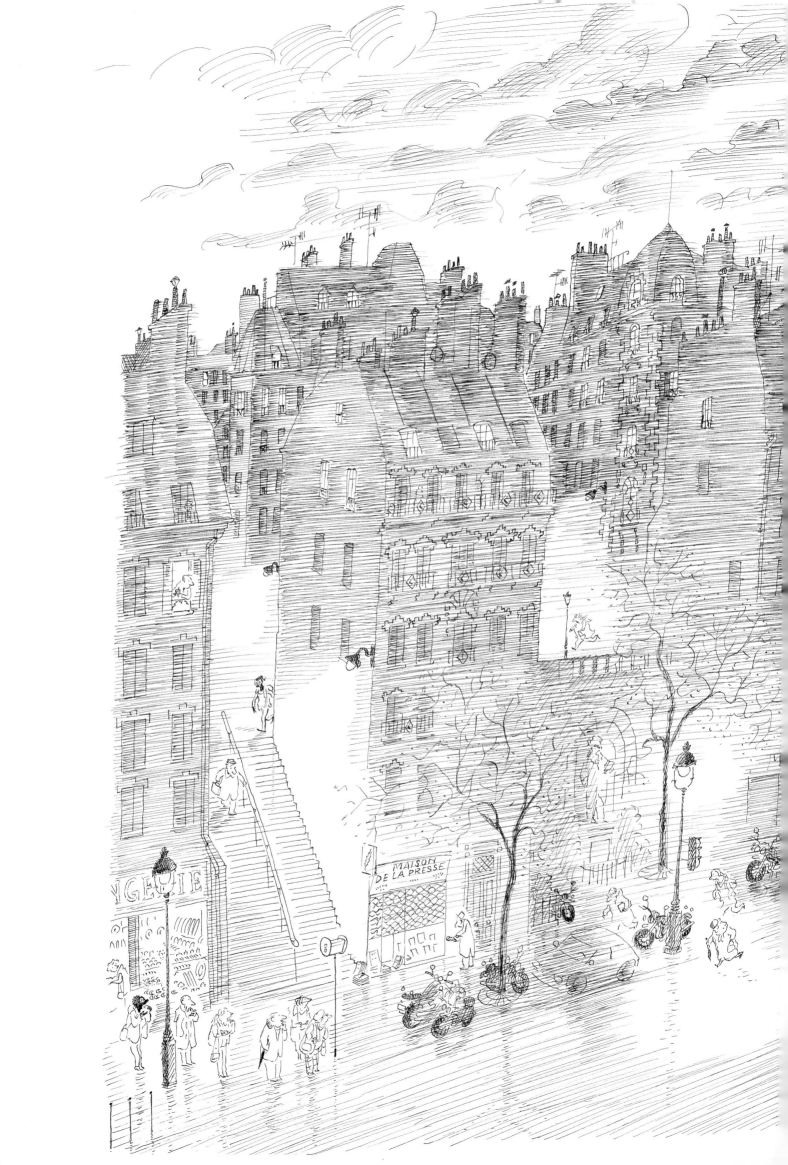

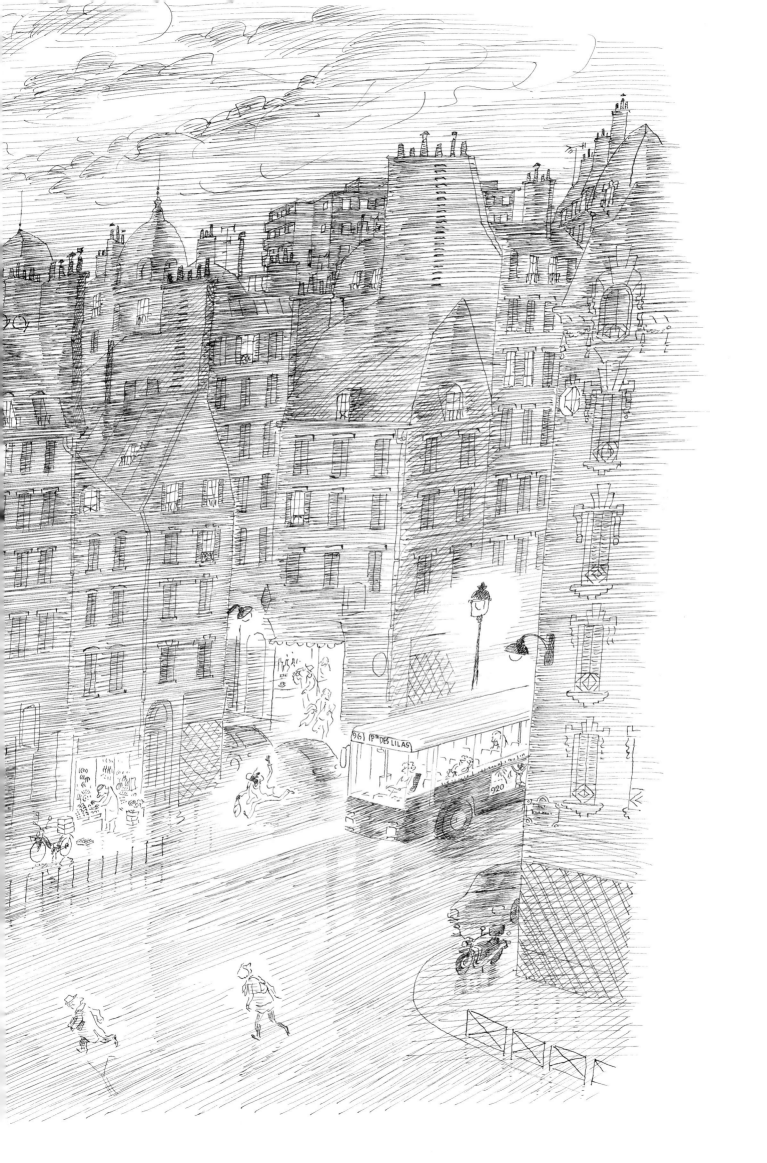

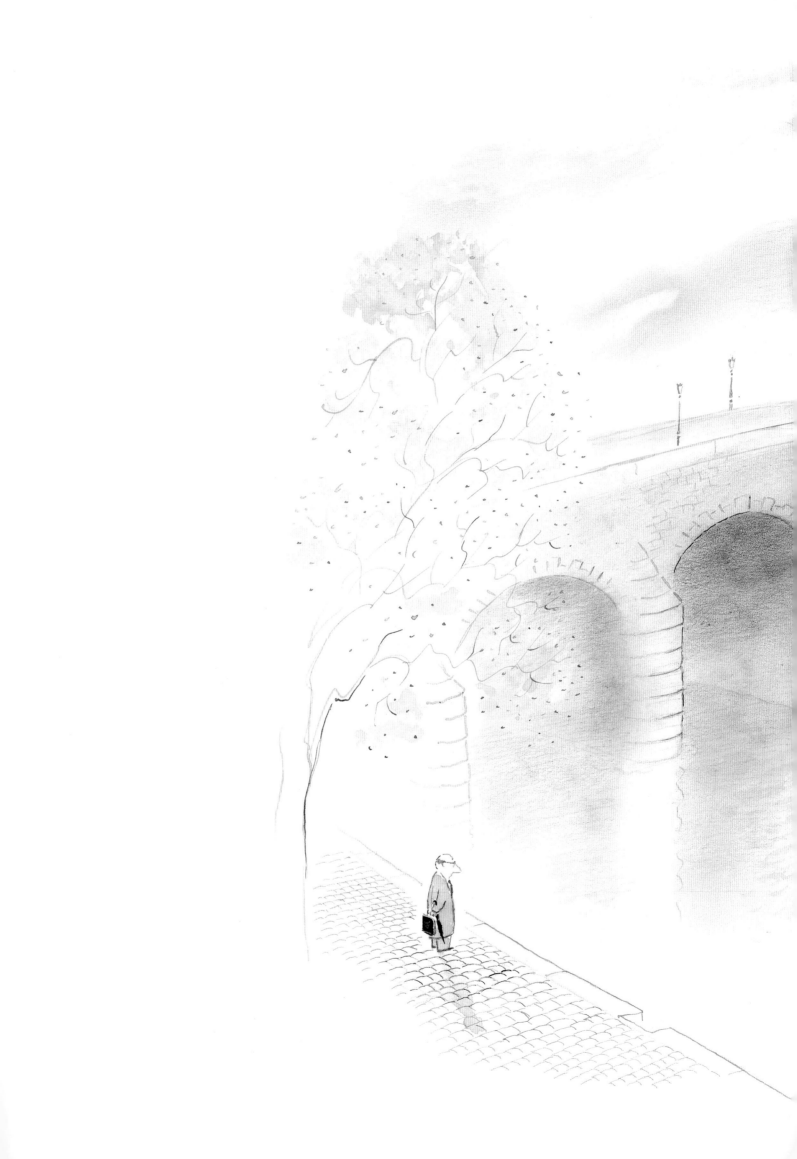

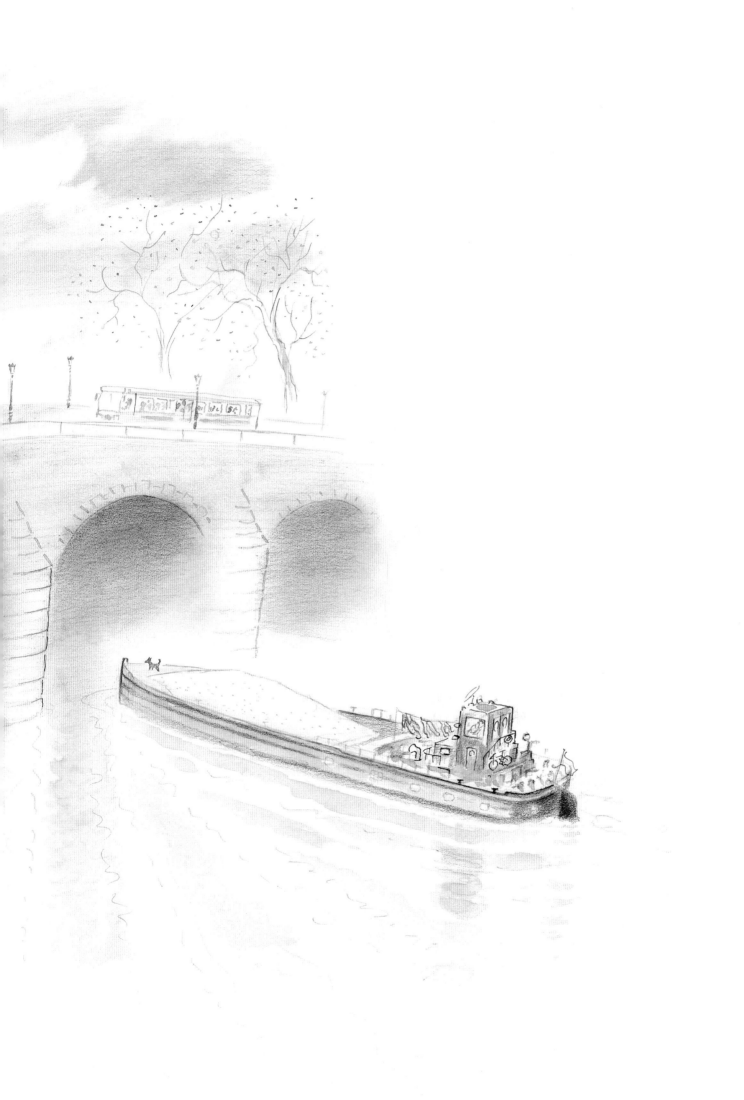

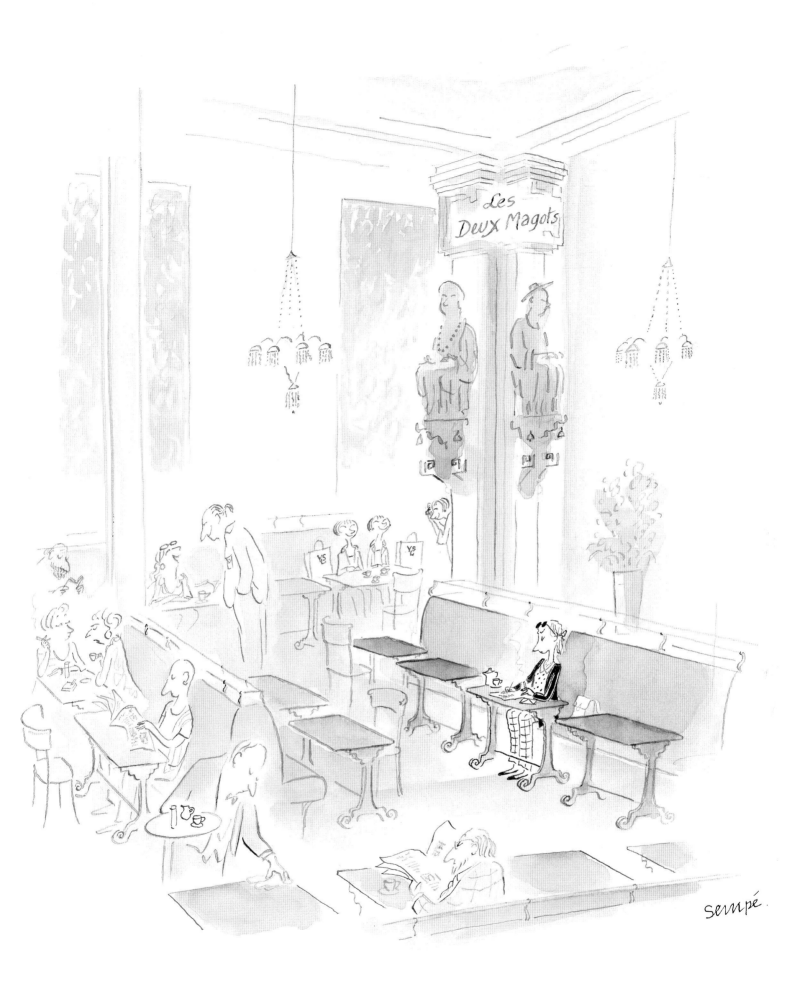

Dear Mother and Father,

Thank you for my trip to Paris. Aunt Béatrice is very welcoming, though maybe a little uptight. I write from this café; perhaps at the same table where Simone de Beauvoir wrote her manifesto The Second Sex. It is desirable that I tell you am not returning on the 6:20 train on Thursday, but on the 8:20 on Friday. My decision is irrevocable.

First published in the United States of America in 2007 by
Universe Publishing
A Division of Rizzoli International Publications, Inc.
300 Park Avenue South
New York, NY 10010
www.rizzoliusa.com

Originally published in French in 2001 as *Un peu de Paris* by
Éditions Gallimard

2007 2008 2009 2010 / 10 9 8 7 6 5 4 3 2 1

ISBN-13: 978-0-7893-1571-7

Library of Congress Control Number: 2007922373

Printed in China